Contents

Why the 35mm SLR?

Since it first arrived on the photographic scene, the 35mm SLR camera has been the favourite tool of the hobby and professional photographer alike. It is a near unbeatable package of convenience, portability and adaptability. But what exactly makes it such a good choice?

Single Lens Reflex

The single biggest advantage offered by the 35mm SLR camera is the thing that those three simple initials refer to. They stand for Single Lens Reflex – a phrase that means a great deal to the dedicated photographer. If you took the lens off of an SLR camera (their second advantage – more of that later) you would find yourself looking at a mirror. And if you tilted the camera away from yourself you would see a bright screen positioned over this mirror. This, and the bulging lump on top of the camera perform a vital function.

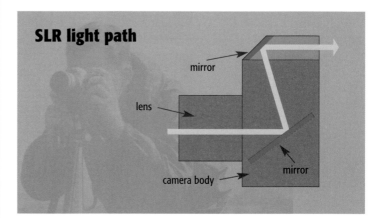

SLR light path

mirror

lens

camera body

mirror

The scene in front of your lens is reflected upwards through the screen above it by the first mirror, and then off a second mirror housed in the distinctive lump. From there it is bounced to the viewfinder on the back that you look through. The technical term for this system of redirecting the light is a Reflex Viewing System. Put very simply, it allows you to look directly through the lens that is actually taking the picture so that what you see in the eyepiece is exactly what you get in your final image. Most of the other types of camera on the market use indirect viewfinders that make it difficult to judge whether you have missed out vital parts of a scene. Once you start using the Single Lens Reflex camera this becomes a thing of the past.

Nikon

F100

ABOVE **This is the mirror that makes it possible to view through the lens, to change the lens in full daylight, and to use all sorts of photographic equipment that you may not have thought about.**

GETTING THE BEST FROM YOUR
35MM SLR CAMERA

GETTING THE BEST FROM YOUR
35mm SLR CAMERA

Michael Burgess

photographers'
pip
institute press

First published 2004 by
Photographers' Institute Press / P.I.P.,
166 High Street, Lewes,
East Sussex, BN7 1XN

ISBN 1 86108 347 5

A catalogue record of this book is available
from the British Library.

Publisher: Paul Richardson
Art Director: Ian Smith
Production Manager: Stuart Poole
Managing Editor: Gerrie Purcell
Editor: Clare Miller
Designer: Andy Harrison

Typefaces: Meridien and Formata

Colour origination by Icon Reproduction, UK

Printed and bound by Stamford Press (Singapore)

About the author

Michael Burgess took up photography on being given his first 'decent' camera, in the form of a heavy Zenith SLR, when he was just 16. He studied photography at school and his interest in it continued and grew from there. More recently he began selling his images to magazines with accompanying articles and to date has had his work published in 16 different magazines. He has also been commissioned to do portrait shots by many friends, colleagues and acquaintances and has written and photographically illustrated a book on classic cars.

When the photographer presses the shutter button a mirror flips up out of the way of the light to reveal the shutter behind. This in turn opens to record your image on the film. When it has finished the mirror drops back into position with a satisfying clunk, and you are ready to take your next picture.

As this mirror protects the film from any stray light it also allows you to change your lens. Basic cameras come with a fixed lens that you cannot change. While fine for

ABOVE **With the push of a button and the twist of your wrist the lens comes off and you can change it for all manner of other lenses for all sorts of photographic tasks.**

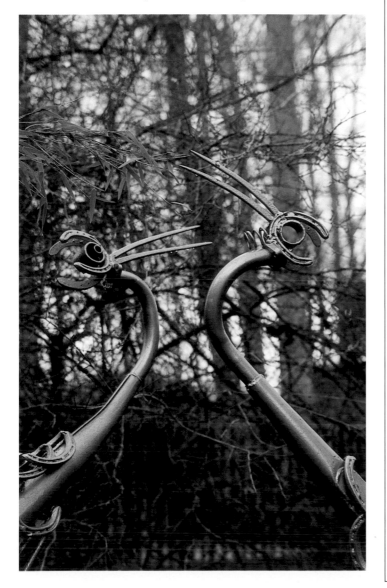

LEFT **Using the zoom control you can frame your subjects perfectly. Exotic sculptures like these, often displayed out of reach, can be isolated against their background and made to fill the frame in a way that would make many compact cameras struggle.**

ABOVE The fiendishly effective multi-zone metering systems on the modern SLR make easy work of even the trickiest abstract subjects.

ABOVE Add a tripod and a little thought and you can turn water into a soft sculpture like this with ease.

day-to-day holiday snaps, this basic lens can soon start to feel like a hindrance to your photography. Especially if you find yourself becoming more ambitious in the techniques you wish to try out.

Lenses

With the SLR a change of lens is just a push of a button and a twist of the wrist away. The light cannot get to your film and ruin it, and the range of lenses available for most cameras is truly breathtaking. The only limit to your lens collection is the depth of your pocket. Most people automatically lean towards the mighty telephoto lenses so beloved of professional sports photographers, but one look at the price tags on some of these is enough to make even the most hardened photographer consider taking up

ABOVE Add a couple of flash units and a sheet of black cloth and you are well on your way to turning out graphic still-life images of this nature.

needlework. However, there are cheaper lenses available that will provide a good introduction to using them. Medium telephoto zoom lenses are now very affordable, as are moderate wide-angles to get more on to your frame of film. Things only get really expensive when you stray outside the mainstream arena.

Film

The third advantage lies in the film itself. 35mm film was first introduced to still cameras in the 1920s. Before that

ABOVE Getting in close is easy with an SLR as you actually look through the picture-taking lens. Tiny details start to take on a new meaning as you can now fill the frame with them and make them the focus of your image.

ABOVE Get in close with the wide-angle setting on your zoom lens (this comes as standard with almost all 35mm SLRs these days) and you can turn even the best-known landmarks into striking photographs.

LEFT Landscapes with no obvious focus can be made into interesting pictures with a little thought and a few simple compositional tricks.

ABOVE Portraits are easy to produce with an SLR. Add a couple of lights and you can achieve good results.

RIGHT Add the pulling power of the telephoto lens and you can make interesting pictures out of all sorts of novelty items.

ABOVE Top quality lenses combined with the finest 35mm films will allow you to capture striking, brightly coloured images like this.

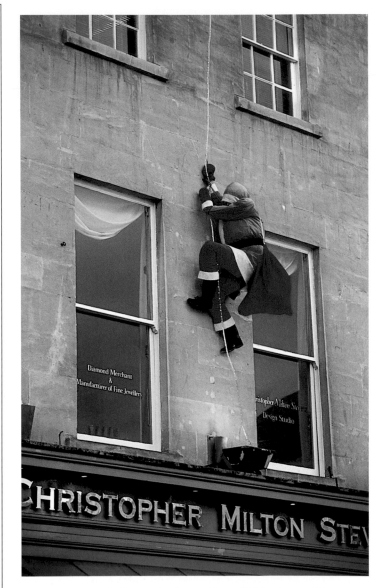

people used roll film (which is still available, but seldom used outside the professional world), sheet film or glass plates (which still have their devotees). Leica came up with the idea of using 35mm movie film in a stills camera and started a revolution that has rolled down the years to today. No other size of film offers such a wide range of film types. From slow, fine-grained films capable of being enlarged to billboard size to fast, coarse-grained types that enable you to come away from the darkest concert venues with useable

results. There really is something for everyone, and those who restrict themselves to only a single make and type of film are doing themselves out of some very enjoyable experimenting. There is film for colour prints, colour slides and even black and white – despite what some of the smaller '1 hour photo' shops might have you believe there is still a thriving black and white industry out there. A lot of people process their own black and white images at home,

RIGHT Side-lighting can really bring out the character of statues and memorials, and with an SLR you can be sure that you will do them justice.

BELOW Pop your SLR onto a tripod and a whole new world opens up. Shutter speeds numbered in seconds can produce results like this. Stationary figures are faithfully recorded, while moving objects and people are reduced to interesting blurs.

RIGHT Fast, modern autofocus systems backed up by top-notch metering systems allow you to snatch 'action' pictures as they happen.

and many towns have somewhere that hires out darkrooms if you want to try it before spending money kitting yourself out. And few things can rival a good black and white image for pure simplicity and impact.

Early 35mm cameras could be tricky to load, and there were often complaints from photographers who found out too late that their films had not wound on properly and whole rolls of film had been lost. The film manufacturers' answer to this was a range of 'easy-load' cartridge formats: 110, 126, Disc – they all had their day and are now fading

ABOVE AND RIGHT What you get with a basic compact camera, and what you will get with a standard 35mm SLR. The difference between a lot of squinting, and a nice, clear image.

ABOVE The classic image of the meerkat is easily obtained by fitting a telephoto lens to your SLR.

LEFT Simple humorous pictures add life to any photograph album.

quietly into the distance. APS film, with its three-picture format, was touted as the replacement for 35mm, but at the time of writing its long-term future does not look promising.

Modern technology has come to the rescue of 35mm SLR cameras. Most modern SLRs have simple film-loading systems that are as easy as any of the cartridge and compact systems. Simply pull the film out to the red mark and close the camera back. The motor does the rest. Some of the cheaper models with manual wind-on levers do still require a certain amount of dexterity and film threading, but do not let that put you off. Once you master the basic tricks and

learn to watch for the tell-tale signs of a misfed film there is nothing to fear.

Looking directly through the lens of your camera has other advantages. You can get in really close with the right lens, filling the frame and achieving results that rival those seen in many magazines.

LEFT Black and white portraits have a simplicity favoured by many.

BELOW Groups in black and white often have a certain 'something' that can be lacking in more common colour prints.

Filters can be screwed on to the front of your lens to create sunsets at any time of the day, make the sky look bluer and water look deeper, as well as getting rid of many of those irritating colour casts that occur when photographs are taken under artificial light. Pictures of people in period costume can be given an authentic sepia hue, and pictures taken on the beach on a dull day can be brought back to life with suitable warm-up filters.

ABOVE Black and white pictures are more difficult to date and this ambiguity is often employed as a technique.

There are 35mm SLR cameras out there for any budget. Admittedly, the cheaper models will not offer you anything in the line of automation, but they will still be capable of giving good results with a little thought and care. For slightly more money there are more complex, but often easier to use models with a large array of automated features. At the top of the range are the very expensive professional cameras. Not ideal for starting photographers, but perhaps something to aspire to.

17

Buying
your SLR

BELOW The basic SLR body with a
standard-length zoom lens.

Having made the decision that the 35mm SLR is the
camera for you, where should you look for your first
model? Unless you have a reason for choosing a very
specific model, the place to go is a specialist camera shop.
This can either be your local independent camera shop or
one of the larger chains. Places where you will get good
advice rather than a hard-sell from commission-based sales
staff in outlets that also sell things like televisions and
videos. Camera shops are usually staffed by enthusiasts who
are likely to have used the equipment you are looking at, or
at least something very like it, and in the event of problems
will be able to answer your questions.

Some of the larger store chains that sell a limited
selection of cameras might be able to offer you a marginally
better deal at the point of sale (never be afraid to ask smaller
shops to match prices or deals, they can be surprisingly
obliging), but they then lose interest. Bring your first roll of
film back to a proper camera shop at a quiet moment and
they will usually be happy to go through any problems with
you, a reaction you are unlikely to find at a larger store.

Before you walk into your chosen shop, do yourself a
favour by carrying out a little research. News-stands are

ABOVE **The twin-lens kit. With one of these, there are very few subjects you will not be able to tackle.**

awash with camera magazines testing the latest and best recommended equipment. Invest some money and learn something about what is available and at what sort of price.

Work out a budget that seems to cover all your requirements. Then be prepared to add around 10% to it to cover all those little extras. You may well find that these are offered at a suitable discount if you buy them at the same time that you buy the camera. Don't go overboard in response to all the suggestions that will be made by the salesperson, but do try to keep your mind open to a bargain. I will offer some suggestions for helpful extras later in the chapter, but now we need to look at the hard information on what sort of camera to buy.

What sort of SLR?

Your first choice when you decide to buy a 35mm SLR will be between manual and automatic. With a manual camera you set everything yourself. You thread the film on to a take-up spool to load the camera, wind the film on with a

Viewfinder information

focus point

exposure mode

metering pattern

focus confirmation

125 F8.0 P 18

frame counter

exposure information

thumb-turned lever, and twiddle all the other dials yourself. You will be responsible for the focus, the exposure (of which more later) and everything else.

An automatic camera does much of this for you. You drop in your film cassette, pull the tip of the film out as far as indicated by a mark inside the camera, close the back and the film is wound on for you. Once you switch on the camera and press the shutter button down part way a complicated but very effective system focuses the lens for you, and lots of little figures along the bottom of your viewfinder tell you that the camera has worked out all the exposure details for you. Now all you need to do is press the shutter release button all the way down and you will have taken your first picture.

So why bother with the hassle of a manual camera, if an automatic can do it all for you? There are two schools of thought on this. By starting with a basic (and often cheaper) manual camera you are learning about photography. Terms like shutter speeds and f-stops will come to have meaning for you, and in the early days you can expect to get fewer really good images as you fumble with the controls or make what you will later see as simple mistakes.

If you opt to spend a little more money and buy an automatic camera, your immediate results will be better. However, you will learn very little about the process of photography itself. You may have a selection of subject specific exposure modes to play with but a lot of the terminology will pass you buy and, if you decide to take your photography further, you will need to learn these later.

> If you opt to spend a little more money and buy an automatic camera, your immediate results will be better. However, you will learn very little about the process of photography itself

Subject-specific program modes allow you to tailor the look of your finished photographs to suit different kinds of subject. For instance, a 'sport' programme might give you a shutter speed that can freeze movement, while a 'landscape' program will capture the greatest depth of field.

Likewise, an automatic camera may only have one form of metering system to work out how much light needs to reach the film. This is usually a complex multi-zone system that measures the light reaching the film from anything up to 45 points and compares it with thousands of scenes in its memory. From this data it makes an informed decision and sets the exposure variables accordingly.

Other cameras include alternative metering patterns for those rare occasions when the multi-zone systems may get it wrong. The most commonly seen is centre-weighted, which gives a bias towards the reading it gets from the centre of the frame over that which it gets from the edges, on the principle that the centre is where the main subject is most likely to be.

Spot metering is another popular option. This takes a reading from a very small area of the picture frame. When used properly it offers incredibly precise metering. However, used without thought it can lead to major exposure errors as readings can be taken accidentally from unsuitable parts of the scene.

The most common route into photography is to buy a manual camera to learn with, then move on to a more automated camera to make things easier at a later stage. If you are studying photography for a qualification, you will

'Subject-specific program modes allow you to tailor the look of your finished photographs to suit different kinds of subject'

Metering patterns

metering pattern

centre-weighted

spot

certainly be expected to follow this route, but as a pure hobby photographer the choice is yours.

As you make your way up the price range, cameras that offer fully automatic and manual options in one are available, often at surprisingly reasonable prices. These tend to be aimed at established hobbyists who want the option of using manual for more creative results, and a fully automatic mode for when they just want quick images. These are excellent general cameras, and if your budget permits I would wholly recommend them.

Above these mid-range cameras are those aimed at hard-core photographic enthusiasts and professionals. And their price tags reflect this. It is very easy to spend comfortably over your budget, and as a beginner you will probably not get any benefit from it. Save your money until later when you are certain that you are going to make photography your long-term hobby.

Camera systems

Before choosing your first camera, consider the other cameras available in that manufacturer's range. Just because you are buying a beginners' camera now, does not mean that in two or three years' time you will not want to move on to something more challenging. And you will want all the accessories and lenses you have acquired to fit it. The main manufacturers, such as Nikon, Canon, Minolta and Pentax, all offer camera ranges that can comfortably cover all but the most demanding uses. Nikon currently hold the record for having the largest range in the world, and Canon are not far behind. Just remember that each make has a unique lens mount, so once you have purchased a large range of Canon-fit lenses, you are locked into buying further Canon cameras unless you wish to spend serious money replacing all your camera lenses.

As with buying any appliance, every range has its devotees. At the risk of upsetting vast parts of the photographic community, I would say that all the cameras currently on the market will give you good results. Some of the more expensive ones will hold up better under hard use, but there are no 'bad' 35mm SLRs currently for sale in the domestic market. There are some that I choose not to use because I find them ergonomically lacking, and others I find

'Before choosing your first camera, consider the other cameras available in that manufacturer's range'

LEFT Don't be afraid to spend good money on a top quality lens. Good glass costs money, and your expense will be rewarded with the fine rendition of the complicated tones in complex scenes like this.

ABOVE Fine details on scenes like this can be accurately captured with a good quality lens.

tricky for my hands to get to specific controls on, but in every case I know of other people who love them dearly and would use nothing else. So find a camera that suits you, and don't let anyone put you off it.

What lens?

As mentioned in Chapter 1, one of the big advantages of the SLR camera is that it allows you to change lenses. When you buy a compact, you get the lens that is fitted to it and like it, but with an SLR this is another thing that you can choose to suit your taste.

Until reasonably recently all cameras were supplied with a lens that had a focal length of 50mm. This came about due to the fact that this lens had a similar angle of view to the human eye. Therefore any lens with a shorter focal length can get more into the picture and is known as a wide-angle. While anything above 50mm pulls things closer and is known as a telephoto.

But all this changed with the arrival of cheap zoom lenses. These have a variable focal length, replacing whole bags full of lenses with a single device. So now nearly all cameras are supplied with a 'standard zoom' with a range of around 28–80mm. This is fine for general use, and will cover the majority of photographic situations that a beginner is likely to encounter. From a moderate wide-angle ideal for landscapes or close subjects, to a short telephoto for when your subject is that little bit further away.

At some stage you will encounter the photographic enthusiast who will tell you that zoom lenses are not as good as fixed focal length lenses. To a certain extent this is true, but today the differences really are very small. A good quality zoom lens will serve you well for your first steps in photography, and if you really do feel that you need better quality, borrow and thoroughly test a fixed lens before spending your money. You may find that you really cannot see the difference and that you need to look elsewhere to improve the quality of your images.

While you are buying your camera, make sure that you enquire after any special offers or kits available for your chosen camera. You can be sure that the shop assistant will want you to spend as much money as they can get out of you, so they will usually be only too happy to oblige.

Many camera manufacturers offer their more popular camera bodies with kits of two lenses. Usually a standard zoom and a more impressive telephoto zoom of around 75mm–300mm. While you might not think you need such a lens from the outset, if there is sufficient saving to be had now is the time to buy. With this kind of twin-lens kit you can confidently expect to be able to tackle the vast majority of photographic situations. Few normal subjects call for a lens beyond 300mm focal length, and those that do require specialist equipment.

How to choose?

Having made your shortlist, how do you choose between the various models? Once you have satisfied yourself that they all do what you want them to do, only you can make the choice. Handle the camera. See how it fits your hand. Can you read any viewfinder displays easily? Do you like the control buttons, or would you prefer a camera that uses

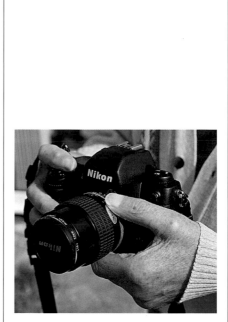

ABOVE **When you get to the camera shop, make sure you handle your chosen camera thoroughly. Does it sit comfortably in your hand? Don't be afraid to handle and compare it with other models if you are not sure.**

ABOVE **The positioning of shutter buttons varies from model to model. Can you reach yours easily? If you have small hands you may find that the larger finger grips on some models make it difficult to reach the button comfortably.**

25

RIGHT Do other, less-commonly used controls still fall easily to hand? Some of these small controls may be heavily used in some areas of photography, and they will be no use if every time you try to use them you poke yourself in the eye.

ABOVE The thumbwheel is the chosen method of overriding the automatic controls on a modern camera. This model has one placed over the thumb grip and alongside the pronounced strap mounting bracket. You will be using this thumbwheel a lot, so make sure such details are not going to be a problem.

the more common dials? Is there an option to turn off that 'bleep' it makes every time it focuses or the shutter fires? If not, will it drive you up the wall after a couple of weeks?

There is an old engineering expression that says 'What looks right, probably is right'. In photography it would be, 'What feels right, probably is right'. If the camera does not fit comfortably into your hand and you cannot reach the controls easily, you are never going to enjoy using it and you will soon start leaving it at home, no matter how tempting the price. While the camera that fits easily into your hand, balances well and feels almost like an extension of your arm is the one for you. No matter how much more expensive it might seem in the first place, if you enjoy using the camera you are far more likely to use it. The camera left in a drawer at home will never take any good pictures.

The frills

While you are in the camera shop you will be surrounded by all manner of interesting gadgets, some useful, some less so. There will be camera bags of every imaginable size and colour, filters, dozens of types of films, tripods and more. If you do not watch your credit card carefully at this stage you could become seriously in debt. So what do you really need?

The only absolute essential, and one that the shop assistant will no doubt already have tried to sell you, is a skylight or UV filter for each of your lenses. If you look at the front of any SLR camera lens you will see that there is a thread in front of the glass element. This is used for

LEFT Take some time to look through the viewfinder. Make sure you can see all four corners clearly, and that any exposure information is easy to read within the screen. If it all looks fuzzy, check out the dioptric correction control on the right. This sets a limited degree of optical correction for glasses wearers and may not be correctly set for your eyes.

LEFT The top plate LCD screen will tell you all you need to know about your camera while in use, often duplicating the viewfinder readout to a certain extent. Make sure you can read it clearly and can understand what it has to say.

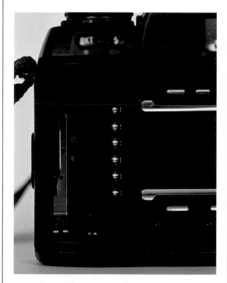

ABOVE Those shiny contacts down the side of the film chamber set the film speed automatically for you. Make sure your camera comes with them (the technical term for it is DX coding) if you want them. Otherwise there is always the chance of setting the wrong speed and messing up a whole roll of film.

mounting pieces of optical glass or resin in front of the lens. These can have many purposes, some of which I will cover in later chapters. The purpose of the UV/skylight filter is basically to protect the front element of your lens from damage and to keep the dirt off it. Far better to replace a relatively cheap filter than the whole lens after it is hit by a flying stone or a clumsy fall.

Both are largely clear, but there are small differences. The UV filter has a very slight blue tinge that cuts through mist and haze at high altitudes, while the skylight has a faint tan tone that imparts a very slight warming to the image. Neither effect is visible on print films, and it is practically undetectable on slide films. It is often mistakenly believed that the UV filter is used for black and white photography,

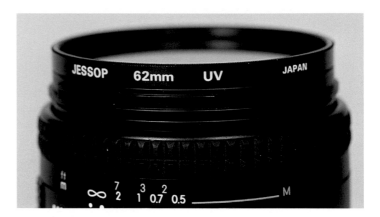

RIGHT What every lens should have. A UV/skylight filter to protect that vulnerable front element from the rigors of dust, damp and condensation. It may not seem cheap at the time, but it will be a lot cheaper than replacing the lens.

and the skylight is used for colour photography. While there is a difference, to all practical intents and purposes they are interchangeable. You will of course also require film, but any good camera shop will give you at least one free roll to get you going, so use that to test your new camera before spending any more money.

The other essential, especially if you have elected to buy a twin-lens kit, is something to carry everything in. The first rule of buying a gadget bag is not to buy anything too small. Every photographer ends up with a selection of different-size gadget bags to accommodate differing selections of equipment (at the last count the author had no less than six bags!), but you will always need one that will hold your whole kit.

Ask what the shop recommends, and do not be afraid of own-brand bags. Look for padding, ease of access and the potential for waterproofing. Few bags come ready-waterproofed, but with a coat of camping waterproofing solution (not applied while your equipment is inside of course) your new camera will be rendered safe from all but the heaviest downpours. Good bags will have moveable internal partitions to hold your camera and your extra lenses secure so that they don't move around as you swing the bag about. There should also be separate pockets for film (it is a good idea to keep used and fresh film in separate pockets), filters, and the hundred and one other little bits that every photographer comes to swear by when they are out and about.

Depending on your chosen field of photography a tripod may well be of use to you. This will hold your camera very

> Ask what the shop recommends, and do not be afraid of own-brand bags. Look for padding, ease of access and the potential for waterproofing

LEFT What no photographer should be without. A good quality and reasonably discrete camera bag. Search until you find one that is easy to get into, comfortable to wear and a pleasure to use.

still for those long exposures, or keep things steady when using your long telephoto lens in murky conditions.

Things like lens cloths and blower brushes look like a good idea when the shop assistant is suggesting them, but they will usually end up cluttering the more distant corners of your gadget bag. Wait until you find that you do need them, as until then they will just be extra unwanted weight to lug around.

Anything else at this stage is really padding unless you have a very specific type of subject matter in mind. Even then you might do well to learn a few of the basics before committing yourself to any seriously expensive equipment that may never get used.

Making a start

Once you have purchased your chosen SLR you may be tempted to begin taking pictures immediately, however the very first thing to do is take out the manual and learn how to use the basic controls on the camera. At first glance the many buttons, dials and switches on your new camera probably look rather complex and slightly intimidating. Don't worry, in time you will make use of them all and once you have used one SLR camera, all others will be easy. Just like driving a car, the basic controls are nearly all in the same places, with only the less commonly used ones hidden away in places you never think to look.

The most important button on your SLR is the shutter release button. This is nearly always mounted on the right-hand side of the top of your camera or, on modern designs, on the top of the hand grip. You press this humble button to turn on the metering system, make the auto-focus work if your camera is so equipped and, finally, if pushed down far enough, to take a picture.

Somewhere else on the top plate of the camera (usually but not always on the left) will be a large dial with which you set either the shutter speeds or the various different programme modes for different types of subjects. Don't worry about these too much at this stage, but keep them in mind for later. They will become very important as your photography becomes more advanced and you want to get the best from your SLR. Among them you will always find a basic, middle of the range setting program for general use. Nikon and Minolta signify this with a simple 'P' symbol (for

Viewfinder information

landscape mode –
a stylized view of a mountain in the distance

macro mode –
a simple sketch of a flower

portrait mode –
simple line drawing of a face in profile

night scene or flash mode –
a head-on figure with a firing flash

sports mode –
a running figure from the side

LEFT The camera command dial. A simple control around which much of your photographic life will revolve. It allows you to set the program of your choice, as well as providing a degree of manual override.

LEFT The shutter speed dial as found on fully manual cameras. It allows you to set the exact shutter speed you want, then allows the metering system to tell you what aperture speed to set. Note the lift and drop film speed setting within the dial.

'program'), Canon shows it as a green square, while Pentax currently employ a jolly green smiley face for their general purpose program.

You can make your pictures look subtly different by using different combinations of apertures and shutter speeds. As you become more proficient with your camera you will start to use these more. In simple terms, your camera is a light-tight box. The film sits across the back of this box, and there is a hole in the front of it. In order to get a photograph, you have to let a carefully controlled amount of light on to the film. To this end there is a shutter over the hole that can be opened for a very short and precise amount of time. These amounts of time are measured in fractions of a second such as 1/125, 1/250, 1/500 and so on. Top quality

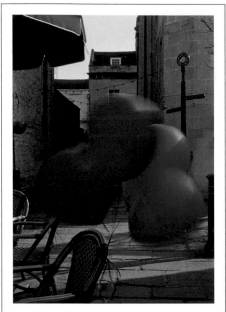

ABOVE A slow shutter speed (1/15 or 1/30 of a second) records moving objects as featureless blurs.

RIGHT While a fast shutter speed (1/250 of a second or faster) freezes the movement.

cameras might go as fast as 1/4000 of a second, and at the other end of the speed range shutter speeds of well over a second are common.

The shorter the length of time the shutter is open, the more action and movement is frozen, while with a longer shutter speed, moving objects record on the film as simple blurs. The light the shutter lets in comes through the lens (so it is important to make sure you don't get any fingerprints on it) and is focused by several groups of glass

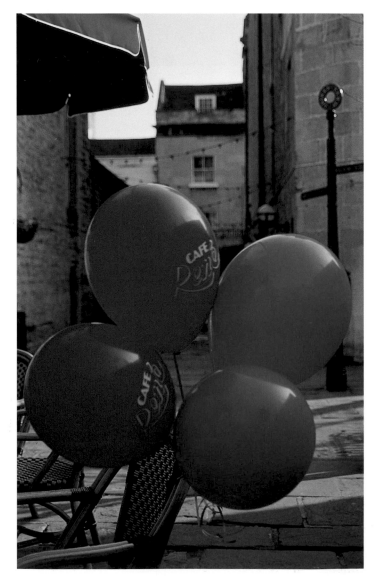

elements. Hidden between these elements is an adjustable hole, the aperture, which also limits the light reaching the film. By opening and closing this aperture you can choose the shutter speed that most suits your subject matter and control the depth of field within your photographs.

The aperture size is designated in f-stops. These will run from f/4 to f/22, or even f/32 on some lenses. The higher the number, the smaller the hole and the less light reaches the film. So the smaller the aperture, the longer the shutter will be open – or the slower the shutter speed – and the less movement will be frozen on the film. But at the same time as slowing the shutter speed, the smaller aperture gives

ABOVE A wide aperture (f/4 or f/5.6) means a shallow depth of field is recorded on the film. Here the flowers closer to the lens are in focus, while those at the back are not sharp.

LEFT While selecting a smaller aperture (f/11 or f/16) brings all the flowers into focus from the front to the back of the picture.

more depth of field. This means that more of the photograph from up close into the far distance will be in sharp focus. Ideal for landscapes, but less so for running children who will record as little more than faceless blurs.

This may sound complicated, and the camera will probably do most of it for you, but it is worth mastering this simple principle before you start: wide aperture = fast shutter speed and frozen action; small aperture = deep depth of field and blurred moving subjects.

This is where those 'subject specific programs' come in. Using these the camera sets a shutter speed/aperture combination that suits the subject matter. How does it know what you are photographing? Simple, you tell it. On the command dial will be a selection of small symbols that

RIGHT The same principle can be put to good use when you want to do away with distracting backgrounds. Here the standard program has given sufficient depth of field to make the person sitting on the bench behind the model a distraction.

FAR RIGHT By selecting a wider aperture the background figure is thrown out of focus and the viewer's attention is concentrated on the model. The technical term for this process is 'differential focusing'.

indicate different subject types. A typical range might include a landscape mode that gives a bias in the exposure towards a deep depth of field, and a sports mode that does the opposite. It keeps the shutter speeds up at all costs to freeze the action.

Film speeds

Film speed	Advantages	Disadvantages
50 ISO	Fine grain and bright, saturated colours mean superb large prints	Slow speed means using tripod is essential in all but the brightest conditions
100 ISO	The standard film speed until very recently. A good choice for normal conditions	Can still need careful handling in low light conditions
200 ISO	The current standard film speed for SLR camera use. Still fine-grained for its speed and capable of producing quality large prints	Grain not quite as fine as 100 ISO film but, to be fair, you would have to look very carefully to spot the difference
400 ISO	Ideal for slightly poorer lighting such as overcast or winter days. Also allows faster shutter speeds for action photography or hand-holding telephoto lenses	Grain now more prominent than with slower speeds. Could be a problem if you want large prints
800 ISO	Capable of freezing most action and getting a picture in almost all outdoor conditions	Muted colours and very noticeable grain
1600 ISO	Good for even the worst outdoor conditions and most indoor venues	Coarse grain and very soft colours
3200 ISO	Good for anything except for complete darkness. It may not be perfect but you will at least come away with some sort of photography for your efforts	Grain, grain and more grain. And only available in black and white at time of writing

Film type

Film type	Advantages	Disadvantages
Colour slide	Bright, accurate colours. No secondary printing stage to get in the way of your careful planning. Ideal for publication	Small originals difficult to view. Difficult to hand around a group of friends. Need to be projected to do them real justice
Colour negative	Quick to get processed. Easy to view and hand around. Print film is cheap and a wide range available	Poor quality processing in some areas. Results can be different from the way you visualized them as different papers and chemicals produce differing results
Black and white print	Can be home-processed easily. Graphic results unlike anything you ever get from more conventional colour images	Mass-processed results always disappointing. Home-processing smelly and messy
Black and white slide	A unique result	Only available from one manufacturer. Slow processing. Expensive

Choosing a film

Choosing your camera and lens is just the start of the variables you can introduce to your pictures when you start out with a 35mm SLR. Your choice of film has a big impact on the look of the final image as well.

35mm film (135 size in technical terms) is the most popular film size ever produced. It was developed from movie film stock by Leica way back in the 1920s and the camera world has never looked back. Over the years it has replaced a huge range of competitors, and outlasted many that were introduced after it due to it being smaller, easier to handle or available in a wider range of types and places.

Common to all film types is the reference to film speed. This is a measure of the film's sensitivity to light. It is given as an ISO or ASA rating and the higher the number, the less light the film needs. Typical day-to-day speeds are 100 (for bright conditions), 200 (for general use) and 400 (for low light or subjects that need a fast shutter speed to freeze subject movement).

However there is a trade-off of quality for speed. Put simply, the faster the film, the lower the quality of the final image. So to get the best from your camera, you should always use the slowest (lowest number) film that you can in the circumstances, particularly if you intend to make large prints from your results. Not that long ago 400 ISO film was regarded as being suitable only as a last resort, so poor were the results. Now 400 ISO film has improved beyond recognition. 400 ISO film is often used as the standard film speed in modern compact cameras, and you would have to

> Your choice of film has a big impact on the look of the final image

RIGHT Loading a manual-type camera is harder than the automatic types, but hardly difficult. Simply pull out the film tip and thread it into the slot of the take-up spool under the wind-on crank.

The difficulty in obtaining black and white film has had a side effect on photography. Getting decent processing is getting harder. Washed-out prints are becoming more common, and if you do not wish to start processing and printing your own (which is quite an undertaking at home) be prepared to have to seek and pay serious money for decent processing.

Processing speeds also vary widely. Colour print film can be ready in as little as half an hour in a high street shop, while black and white can take anything up to three weeks. Slides vary widely as they often go back to the manufacturer, and their workload can vary greatly during the year. Turnover time can be anything from by return of post to two weeks.

Buying your film

When you are buying film of whatever type, be prepared to pay sensible money for the right stuff. Just because you are using a good quality camera, do not expect to get satisfactory results unless you use suitable film. Stick to the main brands for your early experiments, and make sure it is in date (all packages will have a use-before date printed on them). By all means buy multi-packs to save money, but be

aware of the expiry date and make sure they are not left lying around for long periods of time. If you need to store film, wrap it in a plastic bag and put it in the fridge. This will keep it fresh well past its official use-by date. Remember to take it out 12 hours before you want to use it so it has time to warm up thoroughly, otherwise it will be brittle and could snap in your camera.

Loading your film

It is vital that you get this basic process right or you may find that an entire roll of fantastic pictures that you thought you had, has in fact not been taken. Ask the camera shop that sold you your new camera to either demonstrate the procedure, or better still to give you an old film to practise with. Follow the instruction book carefully to load your old film. Once you think it is properly loaded open the back to check. Keep practising until you are completely confident with what you are doing, and only then load your new film.

Most modern SLRs have a built-in motorized film wind-on mechanism that just requires you to pull out the film leader until it reaches a clearly marked spot then close the camera's back. The motor does everything else for you.

Older designs with a manual wind-on require you to thread the film into a slot in the film take-up spool and

LEFT Now operate the shutter and wind-on crank a couple of times until you can see the film has been firmly taken up by the spool. Close the camera back and fire a couple more frames before you start taking pictures.

ABOVE **If the person is the focus of your shot then you need to get in closer than this.**

LEFT **Even this shot allows too much distance between camera and subject.**

RIGHT **Fill your frame with your subject and your photographs will instantly improve.**

carefully wind it on by alternately firing the shutter and cranking the wind-on lever. This takes rather more care than the more modern type, but is a technique soon mastered.

If you have a manual camera, there is an old pro's trick to check that your film is loaded properly. Each time you wind on the film, take a look at the rewind crank on the opposite side of the camera. This should turn in time with the wind-on lever. If it does, you know the film has been properly loaded.

ABOVE Conventional wisdom and human laziness suggests that most pictures should be taken in the horizontal (or landscape) format. After all, the world is generally a horizontal place, especially where landscapes are concerned.

RIGHT But by turning your camera up on end (into the portrait format) you open up a whole new world of compositions and effects. When you think about it, all sorts of landscapes have a vertical element, and this way you can make the best of them.

Away you go!

So you have your new camera with the film loaded and the handbook in your pocket just in case everything comes to a stop and you cannot think why. It is time to take your first film. Don't worry too much about your location when you take this first roll, though obviously it helps if it is a place you consider attractive and pleasant.

There are three useful things that it is worth keeping in mind when taking your first shots.

● Get in close. Fill the frame with your subject, whether you do it by physically walking closer to your subject or making use of the zoom control on your lens.
● Don't be afraid to turn your camera up on end to take your picture in the vertical format. There are many subjects that are better with a portrait rather than a landscape frame. Of course, all situations are different and there is no one rule for any given subject, but it is always worth having an open-minded approach and considering all options.

ABOVE Always cast your eye over the background before taking your picture. Things 'growing' out of people's heads and shoulders in photographs can ruin a good picture.

● Check the background to your subject before you press the shutter button. Especially if you are using the landscape mode that gives you lots of depth of field. Street lamps are not supposed to look as if they are growing out of people's heads. Neither are television aerials nor restaurant signs. Make a note of anything in the frame that you don't want to see and find ways to remove it altogether or to lessen the impact it has on the overall composition.

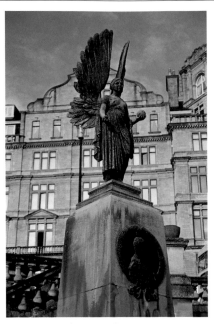

ABOVE **Poor backgrounds can ruin a photograph.
The fussy building behind this statue dominates
the picture.**

RIGHT **But by moving two paces around the base of
the statue you can create a much simpler and
more pleasing picture by isolating the angel
against the plain sky.**

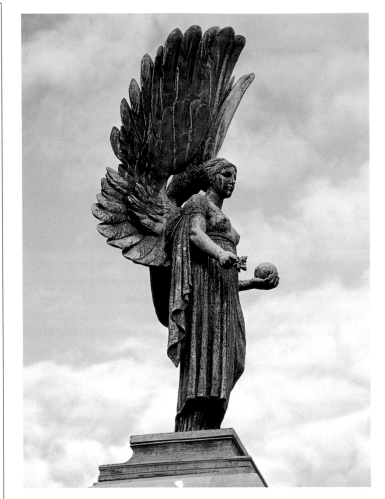

closer to the mountains themselves, lies in creating some
foreground interest. By moving a few feet to the left or right
you may be able to find something to fill the empty void of
the foreground of your image. It might be as simple as the
top of a bush or hedge. Or as complex as a cottage, scenic
hut or horse trough. Anything to make the foreground of
the image more interesting to the viewer.

Maximum depth of field – keeping your foreground and
your background in focus – means a small f-stop (f/11 or
f/16), and it does not matter if you have a longer shutter
speed as landscapes do not tend to move around too much
while you are photographing them. All of which sounds
very much like the landscape program mode on your
command dial. The one shown by the two spiky-looking

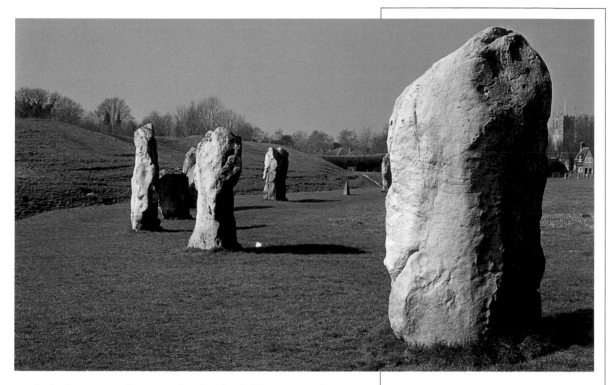

ABOVE By placing these stones in approximate thirds of the composition, you will create a more pleasing image than having them all in a straightforward line across the picture.

symbols that are trying very hard to look like mountains.

It is a good idea to add foreground interest to your image in order to lead the viewer's eye in. Something like a winding track or pathway, roadway or even a river. Something to guide their attention in to the landscape and allow them to take in all the details rather than their mind unconsciously dismissing the more distant details. After all, those distant details were probably what brought you to the

LEFT In the absence of foreground interest, try to find a feature that leads the viewer's eye into the photograph.

ABOVE **You will never be short of foreground interest if you have dogs!**

spot in the first place. Which brings us to a special rule of photography: things seen by the camera nearly always look further away than you remember them. Make sure you look carefully through the viewfinder to see how close things really are as they may well record on film rather smaller than you expect them to.

RIGHT **Here, the line of the beach is tilted diagonally across the picture so that it leads the eye into the picture.**

Classic mistakes

You would not be a photographer if you did not make mistakes. Usually the classic mistakes that photographers have been making for years. Right since Fox Talbot found a way of sensitizing paper and creating the first negative in fact. So don't feel bad if some or even all of the mistakes and errors listed below afflict your first film. Every photographer has made these mistakes, and some photographers with years of experience behind them are still prone to them. The advent of autofocus and fully automatic programme modes has also introduced a whole new range of problems for the modern photographer to contend with.

There is, however, one all-time classic mistake that no SLR photographer can ever make. If you left the lens cap on you would see nothing but blackness, which should be enough of a tip-off to remove the lens cap for anyone. Anyone using an SLR who actually manages to take a roll of film with the lens cap in place is beyond the help of any book.

Finger-on-lens syndrome

Not seen very often in SLR circles, but occasionally you do still see photographs with an edging of pale pink along the side of the image. Usually seen on the bottom of the picture on compact cameras, it tends to appear around the edges of SLR photographs. The cure for wandering fingers is to keep your hand well away from the front of the lens when actually taking your photographs. Even if you have to adjust

LEFT Keep your fingers well away from the front edges of your lens when you take your pictures. Otherwise this is the result.

your focus manually you should remove your hand from the front of the lens before making your exposure. By firmly grasping the camera body and just supporting the bottom of the lens barrel while you take your picture you help to prevent camera shake and you ensure that no part of your hand appears in your picture.

It is easy to misjudge whether your finger is in shot when looking through the lens of your camera. Few SLRs actually show 100% of the film's image recording area in their viewfinder. This is to allow for some small errors in the camera user's framing, and for the processing. When a film is commercially printed it is done on a machine (some of

RIGHT Camera shake is easy to spot as the subject is clearly defined but is covered by directional blurs. It is caused by the photographer accidentally moving the camera at the moment of taking the picture. To prevent this, always set a shutter speed that suits the lens (see text) and press the shutter button gently. Do not jab at it or you will find it is possible to induce camera shake at all sorts of shutter speeds.

these automated monsters can turn out upwards of 25,000 prints in an hour), which always causes some small amount of masking of the very edges of the negatives as the machine clamps the negative onto the printing plate. There is usually only a very small amount of masking, and to allow for this the SLR does not show the very edges of the negative area.

Camera-shake syndrome

If everything in the photograph is blurred then you have been the victim of what's known as camera shake – moving the camera during exposure. There are two causes, and both are easy to remedy. If the picture was taken in good light with a standard zoom lens then there is a very good chance that you need to pay some attention to your camera-holding technique.

Stand with legs braced slightly apart, and the camera held firmly with both hands. Once you have framed your subject with the zoom control, or moved to a suitable place to take your photograph from, gently press the shutter button to activate the focus and metering systems (unless you are using a manual camera). Once the image is focused and the light levels are correct, press the shutter all the way down. If you quickly jab at the shutter button at this stage there is a very real chance that you will jar your camera and the vital end of the lens will still be moving when the shutter tries to record the image. The result will be a blurred image as you move the camera during the exposure.

The other possibility is that you are trying to take a photograph when the light levels are too low. When the shutter speed drops below a certain level (usually around 1/30 or 1/60 of a second) then you are getting to the stage when you simply cannot hold the camera steady and get a sharp image without some sort of external assistance. This could be a tripod, or could take the form of something as simple as a beanbag placed on top of a wall or car door. Anything that will steady your hand sufficiently to give you a sharp image.

If you do want to take photographs in low light conditions, try loading up with a more sensitive film such as ISO 800 or 1600. Your results might not be quite as sparkling as those you get when using your usual ISO 200 film, but at least you will have photographs.

> 'Stand with legs braced slightly apart, and the camera held firmly with both hands'

ABOVE **With the whole image out of focus like this you have either left the autofocus turned off (easily done on some cameras) or not checked the focus before taking the picture. Always make a quick visual check that your picture is in focus before pressing the shutter button. Even the finest autofocus system can fail you on occasions.**

Finding focus

If nothing in your picture is sharp, you are having problems with your focusing. Exactly how you go about solving this depends very much on what sort of camera you are using.

Those using a manual camera will need to keep practising their technique. The focusing screen on manual SLR cameras is usually made up of three distinct sections. The largest outer area has a ground-glass finish which is fine for focusing on large subjects such as buildings, allowing your subject to snap in and out of focus with relatively small movements of the lens focusing ring. There is then a large 'microprism' collar located in the centre of the screen that gives your subject an almost shimmering effect at all times except when the subject is in sharp focus. Finally, in the very centre is a split-image device that you align to any feature on your subject and check either side of the line that splits the small circle. If the two sections on either side of the line are exactly aligned, then your image is in focus. If they are not, then you have to adjust the focus until they are, then everything should be in focus. This is ideal for

focusing on small details or close-ups. With a little practice you will soon find that you can focus easily on all but the most fast-moving subjects with a basic manual camera.

Those photographers using automatic cameras will soon learn that autofocus is not infallible. Occasionally you will come across a subject on which it just will not focus. As most systems work on the principle of contrast detection some systems will have difficulties with bland surfaces, or in very low light. When this happens you will probably notice your viewfinder image moving in and out of focus as the lens tries to lock onto something on which to focus. A certain amount of frantic whirring will also warn you that something is wrong.

On those rare occasions (and they should be few and far between with a modern camera) you will need to select the manual focus option. Some manufacturers place the switch for this on the body of the camera, while others place it somewhere on the edge of the lens mount, or even on the lens itself. The only snag is that autofocus cameras do not usually come with the helpful focusing aids found on manual cameras. All you can do is look very closely at the ground-glass screen and do the best you can. If the light is poor you can't do any worse a job than the camera itself. And if the light is good and just the subject matter is defeating the machine you should have no problems working by eye. Practise a little with no film in the camera when you have a quiet moment and you will soon find the skills come easily.

If you use an automatic camera it is also worth checking that the autofocus system hasn't somehow been switched off while the camera was not in use.

Areas of fog

This is a very common problem that is unique to users of automatic cameras. When your autofocus system cuts in, it usually works out the distance from the camera to the subject from a point in the exact centre of the viewfinder.

While many modern cameras offer you the chance to select any number of focusing points placed all over the image, and some even claim to follow where your eye is looking to choose their focusing point, most default to a central point. It is worth checking whether you have

'Practise a little with no film in the camera when you have a quiet moment and you will soon find the skills come easily.'

these options as they can be very useful. When you have foggy areas it is because the central focusing point has been positioned away from the main subject is supposed to be the main subject and focused on another element in the frame.

There are three ways to avoid this. The first is to use the changing point of focus found on some cameras, as mentioned above. You can also make use of a feature found on all autofocus cameras, the focus lock. Often set by half-pressing the shutter button, this locks the focus before you take your picture. All you need to do is turn that central focusing point towards the element of your composition that you want to be in focus (or any other important part of an image) and gently press the shutter button. You will see the camera focus. Now, without taking that light pressure off the shutter button, press the focus lock button, then turn the camera back so that the picture is framed as you would like it and press the shutter button all the way. It

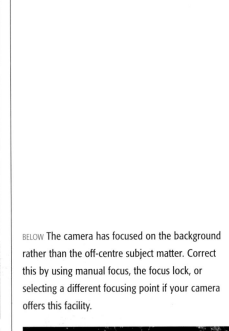

BELOW The camera has focused on the background rather than the off-centre subject matter. Correct this by using manual focus, the focus lock, or selecting a different focusing point if your camera offers this facility.

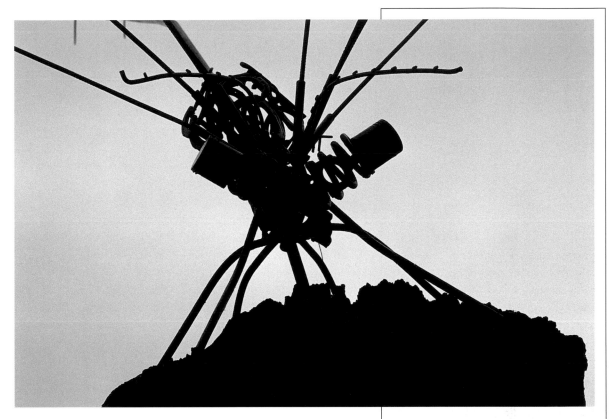

is also best to select the 'landscape' programme mode in order to make the best of the available depth of field. The other simple solution is to switch to manual focus and do it all yourself. A little more effort, but the most foolproof option available to getting the part of the image you want in focus. Don't forget to take the time to set everything back to normal once you have taken the picture.

Silhouettes

You will sometimes find your chosen subject has been reduced to a near featureless black silhouette against a bright background. This is because you have inadvertently fooled your camera's metering system. No matter how good it might be, experience will soon tell you that it can be beaten by some very simple photographic situations and having strong light behind your subject is one of these.

The meter thinks that the brighter light is the more important part of the picture and exposes accordingly. This means the darker part of the picture suffers the fate of

ABOVE A featureless silhouette is a result of taking a picture of something against a bright background. The camera's metering system is fooled into metering for the bright background, the foreground subject is reduced to a black blob. Beat this by using exposure compensation, fill-in flash or spot metering.

turning near black as film can only handle so much difference between bright and dark before it gives up the fight and things turn black. There are several ways to deal with the phenomenon depending on your camera.

If your camera offers the facility of spot metering (taking a light reading off a very small part of your subject) then use it. Take a reading from the darker part of the image and take your picture using this reading.

A quicker option is to point your camera downwards so the brighter light is excluded from the viewfinder and lock this reading by pressing the exposure lock button. All cameras have these. They are sometimes activated by a light pressure on the shutter button, or may be a separate control somewhere else on the camera body. Consult your instruction book to find out where it is located on your camera.

Last but not least, you can use exposure compensation. By forcing your camera to allow more light onto the film you will give the correct exposure for the darker subject and allow the brighter background to burn out to a featureless white. Once again, not all cameras offer you this feature, but those that do usually work on the principle of pressing the compensation button and turning a thumbwheel to adjust the amount to suit. For bright backgrounds a setting of +1.5 is usually sufficient, but experimentation will soon find your own favoured amount to suit your own artistic sentiments.

Orange streaks

Just occasionally you will find bright orange streaks, or even blobs, all over certain sections of your film. This is a rare occurance and one that is normally related to having children around! These bright 'marks' are caused by light leaking onto the film. Assuming that the processors have not been hopelessly careless, the only cause is likely to be that the back of your camera has been opened at some stage with the film in it. The only way to guard against this is to ensure your camera is stored safely out of harm's way.

Filling the frame with the subject

I have mentioned this mistake before, but it is such a common one it's worth highlighting it again. If you only take one thing away from this book, please make it this: fill

> These bright 'marks' are caused by light leaking onto the film

LEFT Any marks with this sort of bright orange colouring mean light has leaked onto your film. It can happen either by accidentally opening the back of your camera with the film in place, or during careless processing.

your frame with your subject! Whether it be family, friend, dog, cat, motorcar or statue. You are recording this image on a tiny piece of film, so make the best of it. Twiddle that zoom ring, or move in closer to your subject. If you find that you can only identify Auntie Flo by the bright yellow anorak she is wearing, you are too far away from her.

Capturing true colour

Is your sky purple and your grass a lurid shade of green? There are two possible reasons for this. If you bought your film from the bargain bin at the local store, I'm afraid you have brought this on yourself. You do need to spend good money on your film to get the best results. Buying film that is out of date, has been sitting in the sun at a beach kiosk or is of some remarkably obscure make is a sure road to disappointment.

More likely it is a processing fault. If this occurs, ensure that it is not a fault of yours, then return your prints to the processor and ask for them to be reprinted.

I hope that your first roll of film has not been too disappointing, and that you are not discouraged from carrying on with your new 35mm SLR. Get out your next roll of film and try to learn from your mistakes. Even if you managed to find every one of the classic mistakes listed in this chapter in your first roll, at least you need not make them again. But you can be assured that every so often you will. Just keep trying and you will improve.

LEFT Any marks with this sort of bright orange colouring mean light has leaked onto your film. It can happen either by accidentally opening the back of your camera with the film in place, or during careless processing.

ABOVE The 19mm lens is usually as wide as most people go, as beyond this distortion becomes too great to be useful. Depth of field is pretty much infinite and all but the closest parts of the image look extremely far away due to an exaggerated perspective.

Change that lens

ABOVE 24mm is the widest of the conventional wide-angle lenses, and can be found as the widest setting on some of the more expensive standard zooms. Depth of field is again plentiful, and the wide-angle effect of objects looking further away than you would expect is still pronounced.

As was noted in Chapter One, one of the biggest advantages of owning a 35mm SLR is that you can change the lenses. And as the viewfinder actually looks directly through the picture-taking lens, you can see exactly what effect any lens achieves. The shutter behind the mirror keeps light off your film so you can change the lens while your camera is loaded without taking any other precautions. Owners of medium-format cameras (think bigger and more expensive versions of the SLR) have to remember to put a metal darkslide in front of their film to achieve the same effect. A small but very useful advantage for 35mm.

So what is available to expand your picture-taking horizons? Well, pretty much anything you can imagine really. There are wide-angle lenses capable of recording a full 180° angle of view that will even show your feet at the bottom of the picture. And telephoto lenses so strong they need a heavy-duty tripod on their own to have even the faintest chance of getting a sharp image. However, prices of this kind of equipment are not modest; there are few areas of photography able to empty your bank balance with such speed as choosing new lenses.

Technically speaking, there are two types of lens and these are divided again into two further categories. These broad categories are wide-angle and telephoto.

All lenses are defined by their focal length, which is expressed in millimetres. As a rule of thumb, the higher the number of millimetres, the greater the magnification of the image on your film. Up until relatively recently all SLRs were supplied with a 50mm 'standard' lens. Exactly how this became the 'standard' is long since lost in the mists of time. Popular theories include the fact that it has an angle of view that approximates that of the human eye; that it is a good, distortion-free focal length and that it is a cheap focal length to manufacture to give decent quality results. For whatever reason, 50mm is still regarded as 'standard'.

So any lens with a focal length less than 50mm is regarded as being a wide-angle lens. The shorter the lens (the lower the length in millimetres) the wider the angle of view and the more you can get into your photograph without stepping backwards. These can be a real boon when you are trying to capture groups at parties or broad landscapes when you physically cannot step back without

ABOVE 28mm. This is as wide as most standard zooms go and offers a good compromise between wide-angle distortion, angle of view and depth of field.

ABOVE 100mm is the ideal focal length for portrait photography as it starts to flatten the perspective of the image. It also provides a useful amount of 'pulling' power to make distant objects look closer.

ABOVE 35mm is regarded by many as being the correct standard focal length for the 35mm format, and offers an excellent compromise between sharpness, depth of field and ease of use.

ABOVE AND BELOW 200 and 300mm are useful settings within the range of your longer zoom lens. They make things look closer to the camera than to the naked eye and offer a chance to fill the frame with distant objects that you might not want to be too close to.

ABOVE 50mm is treated by most as being the 'standard' focal length for 35mm SLR cameras. It approximates the angle of view of the human eye and gives a clear, optically perfect photograph free of major distortion.

ABOVE **400mm lenses are getting into the range of super telephotos that many photographers do not use as they demand the use of either fast film or a sturdy tripod to get the best from them. But in some circumstances, they can be a lifesaver.**

hitting a wall or dropping off a cliff. The only downside is that things look further away.

Any lens with a focal length greater than 50mm is regarded as a telephoto. This means it magnifies the image and can pull distant objects closer. If you can't visualize quite what they would look like, just check out the professional photographers on the touchline of any major football match and you get the idea.

The higher the focal length of the lens the more it pulls things towards you, and the longer the lens gets physically. Naturally, the by-product of this magnification is that the angle of view gets much smaller. Put another way, you cannot get as much into your picture.

Depth of field also varies with focal length. You should recall that the smaller the aperture you set on your lens, the more you will get in focus from the foreground to the background. Just to make things more complicated, the focal length of your lens is also a factor. The shorter the focal length, the greater the depth of field. By the time you reach the likes of 28mm or less, you should be able to get everything in focus from the fairly close foreground to the far distance, even if you are limited to the aperture you can use.

Angles of view

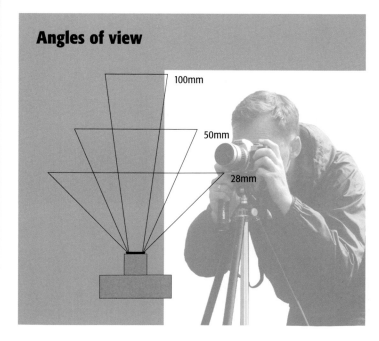

Conversely, you get less depth of field with longer focal lengths. This allows you to focus closely on your subject (such as a person or very small part of the landscape) and only that part of the photograph will be rendered in sharp focus. The background will be reduced to a blur which concentrates the viewer's attention on the important part of the image. This effect can be even more accentuated by choosing a wide aperture/fast shutter speed combination (portrait programme mode if you have one) to reduce the depth of field even further.

Fixed or zoom?

Lenses are available as either fixed focal lengths, or zoom lenses. Your camera probably already has a zoom of some type fitted to it. With a fixed focal length, what you get is exactly that: a fixed depth of focus. There are advantages to buying fixed focal lengths, and I will come to these in a moment. With a zoom lens you have effectively got a whole handful of fixed lenses in one compact package. They are also infinitely variable with a simple twist or pull of the

BELOW A family group of lenses. From left to right we have the 'standard' 50mm, the now standard 28–105mm (or similar) zoom, and a larger 70–300mm telephoto lens.

ABOVE **The anatomy of a lens. At the top, in the picture above, is the lens mount which locks onto your camera body. Beneath that is the aperture ring. Next are the scale of focal lengths and the zoom ring, for changing the focal length. After that is the focusing scale and ring. Finally a lens cap should be kept on the lens to protect it when not in use**

zoom ring so you really can frame your pictures to perfection. And this simple zoom replaces a whole gadget bag full of fixed lenses.

Most modern 35mm SLRs come with what has become commonly known as a 'standard zoom'. With a range of around 28mm to 90mm these offer a stepless range from a moderate wide-angle to a slight telephoto. This range is ideal for general work. From holiday snaps to portraits, the standard zoom will serve you well.

So why buy a fixed focal length lens? Ultimate quality is one reason. For all sorts of technical reasons, a zoom lens will always be slightly inferior in image quality to a fixed lens. The real perfectionist would never consider carrying anything other than a huge bag of fixed lenses, though for obvious reasons this is not as practical and straightforward as having to carry and deal with just one lens.

Fixed lenses also offer faster maximum apertures; they open out as far as f/2.8 or larger. This can give a brighter image for manual focusing and allows the use of slower film in low light conditions. Zoom lenses nearly always have slower maximum apertures on all but the most expensive versions. This can be a limiting factor, but with the advances in modern film technology, it is not the handicap it once was. Faster films make up for the loss in speed and still offer decent image quality.

There are also times when you just don't want to be fiddling about with the zoom control. Portraits are a typical example. You really need to be concentrating on your subject rather than twiddling with the zoom ring every time you take a picture. If you are shooting the classic head and shoulders portrait you will only need to vary your shooting distance by a foot or so as you work, so taking a pace back and forth gives you less to worry about than fiddling with your lens. Your subject will also be happier as they will be more aware of what you are doing.

Many traditionalists may disagree, but there is nothing wrong with using a zoom lens. The quality of a good zoom lens approaches that of all but the most expensive fixed lenses and is fine for general use. If you are going to enlarge all of your images up to 457 x 305mm (18 x 12in) then you will see the benefit of buying a fixed lens or two, but for general snaps there is nothing wrong with using a zoom.

Lens ranges

As discussed above, all lenses are categorized by their focal length, and every focal length offers particular advantages and disadvantages to the photographer. Listed below are some of the more popular types, their names and what you can use them for. While I have given the most popular uses and characteristics for each type, they are not intended to be treated as gospel. Just because a lens is considered to be used mainly for landscapes, there is nothing to stop you using it for producing outlandish portraits or alternative renderings of more traditional subjects. Creativity is a vital factor in photography.

Fish-eye lenses

These have very short focal lengths (often only in single figures) and their front element bulges like the eye of the fish, which gives them their name. The images they produce are equally distinctive. Because of their extreme focal length everything within your image is distorted. There are no straight lines in an image produced by a fish-eye lens. Everything bulges towards the camera in the centre of the frame, and bows away towards the edges. Some fish-eye lenses produce a circular image in the middle of your negative, while others have been slightly optically corrected to at least give an image that covers the whole frame.

Fish-eye lenses were originally developed purely for scientific work, such as photographing clouds for meteorology and wide areas of the landscape from above. Today they are used by hobby photographers purely for artistic purposes. Occasionally you might want to use one for photographing the interior of a building, but usually they are used to create distinctive and artistic images. Generally photographers either love to use them or steer clear of them completely.

Due to the specialist nature of these lenses they are very expensive for the average home user. They do occasionally turn up on the second-hand market, but even there they are still costly. If you are really keen to try these effects it is worth checking out the much cheaper fish-eye adapter discussed in Chapter 6.

'Every focal length offers particular advantages and disadvantages to the photographer'

RIGHT A typical ultra-wideangle lens with its trademark wide and slightly convex front element.

ABOVE The ultra-wideangle lens offers great depth of field and an exaggerated perspective which can be used to create unusual effects.

Ultra-wideangles

This broad category generally covers anything from 17mm through to somewhere around 24mm. There are some lovely zooms available in this range, and there are even some available from the budget independent makers (see page 74), which make sensible purchases even if you do not find yourself using them a lot. Depth of field is pretty much infinite at the wider settings and not bad by the time you get to 24mm.

These lenses are perfect for the architectural or social photographer who simply has to get everything in and may not be able to get themselves into the ideal position to do so. Used with care they can produce largely distortion-free images for general use.

Alternatively, they can be used to produce interesting effects not dissimilar to those acquired with a fish-eye lens. Things nearer the camera in the foreground will be ruthlessly stretched towards the camera, and anything beyond the middle ground will be reduced to tiny specks. Think carefully before you use one of these as a portrait lens if you want to keep your friends! Long-nosed cars can be made to look even more imposing by getting in close to emphasize the long line of the bonnet. Foreground interest can be given particular emphasis with an ultra wide-angle as it will loom large in the frame yet still be in perfect focus. Prices are reasonable for these complicated beasts, but the cheaper versions have far more distortion than the 'own

LEFT Used in a conventional setting, the ultra wide-angle lens creates a stylized view of the world as everything from up close into the far distance is in sharp focus, and things more than a few feet from the camera seem to disappear into the distance.

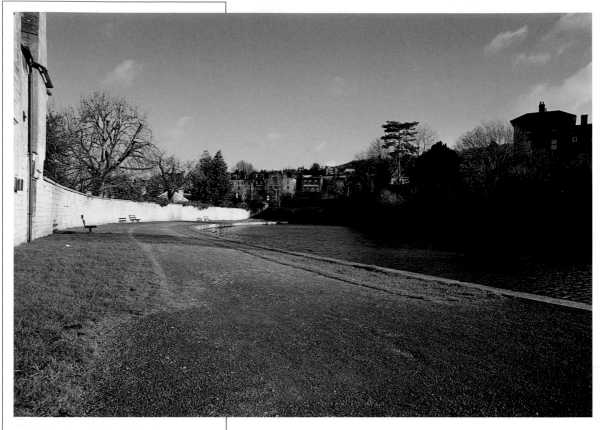

ABOVE **By crouching and using the widest setting on your standard zoom you can emphasize unexpected areas of the foreground to lead the viewer's eye into the main body of the image.**

brand' versions. Some people consider this to be an advantage while others find it a problem. With any slightly more unusual equipment like this it is always a good idea to try before you buy.

Standard lenses

As discussed above, the 50mm lens has long been considered to be the standard lens for 35mm users. There is an equally strong body of opinion that says that the 35mm lens is the 'true' standard. Their arguments on the subject are as long and complex as they are for the 50mm, so I will spare you them here. Let us just say that the 35mm lenses available are all excellent devices and they will serve you well if you prefer to have a slightly wider angle of view as your standard lens.

While fixed standard lenses have become less popular with the advent of cheap, good quality zooms, they still have their place in the gadget bag. Why? To start with they

are usually of a very high optical quality. The manufacturers have had years to get these lenses just right and they now have very little distortion with near perfect sharpness right across the frame.

Fixed lenses also have a very fast maximum aperture (usually f/2 or even beyond) which makes them the perfect tool for low light conditions. They are also small and light. After a day's hiking you will realize how important this is. It is also a very interesting discipline to only have one focal length to play with. While it is somewhat limiting, it forces you to look for photographs where you might not have seen them before. If you are intending to become a 'creative' photographer you will find using this discipline every so often is a useful way of stirring the creative juices.

BELOW Get in low and close with the wider settings of your standard zoom lens to make a dramatic scene of a simple sculpture or feature of a building.

RIGHT Once you have taken a couple of general views of a scene, take the time to increase the setting of your standard zoom to the telephoto section and concentrate on detail.

ABOVE With your macro setting you will soon find all sorts of unexpected details to take up your time. This art deco car badge is almost as interesting as the full-sized automobile it adorned.

Moderate telephotos

These cover the range of 85mm to around 135mm. Before the advent of the cheap zooms the first lens most photographers purchased was a 135mm telephoto, but today you would be hard-pressed to find one. These lenses are generally used for portraits. They give a very slight change in perspective that is flattering to a sitter's features. They are also usually fast lenses allowing the use of slow film and easy focusing if you want to work manually.

Lack of demand tends to keep the prices of these lenses at a steady level, but as with the 50mm standard lenses they have been around a long time and they are optically excellent. They are worth buying as a separate lens only if

LEFT The longer telephoto lenses are useful for getting in close to scenes such as feeding time at the zoo. You would be hard-pressed to get this sort of result from your standard zoom lens.

ABOVE Your telephoto lens is not restricted to things you would rather not get too close to. It is a fine tool for searching out unnoticed details in buildings and the countryside.

you are particularly interested in taking portraits, although if you can get your hands on a good value second-hand one it would be worth having around just for occasional use.

Macro lenses

I mention macro lenses here because they are commonly produced at a focal length of 90mm or 105mm. They are designed to focus down to very short distances to allow you to get in very close to your subject. In general use this means close-up photographs of flowers, insects and anything else that you want to get in really close to.

They are more expensive than the fixed moderate telephoto lenses mentioned above because they are specially designed and optically corrected to get in really close. The technical definition of a macro lens is one that allows a full-size image of its subject to appear on the film (known as a 1:1 reproduction ratio). Many of the lenses listed as macro

these days do not actually manage this level of reproduction, and the term has simply come to mean the lens has some facility to focus in close-up. Optically these lenses are always very good quality, and they can double as excellent portrait lenses using their moderate telephoto capabilities. However, they are expensive so take time to consider whether you require these specialist facilities before buying.

Telephoto lenses

Telephoto lenses are much longer lenses to look at and are available in focal lengths from around 200mm all the way up to a staggering 1200mm (these powerful lenses usually have an equally staggering price tag). In the real world a 300mm telephoto lens is probably about as powerful as most people will require, or be able to use effectivcly. Such a lens will pull things closer and enable you to get decent results at horse or motor racing. It also enables you to fill the frame with small details on large or distant buildings. The downside of such a long lens is a limited depth of field. Your focusing will have to be spot-on if you want your image in focus. Autofocus will do most of it for you, but you will have to make really sure that your focusing point is in exactly the right place, otherwise you will get a picture that is not sharp.

Camera shake is the other problem. Unless you can be really sure of bright light always load fast film when you want to use a 300mm lens. Any shutter speed of less than 1/500 of a second is asking for trouble with a 300mm lens, and if you are using slower than 400 ISO film you could have real problems. The alternative is to use a tripod or rest the camera on a firm surface to keep things steady. Just put some sort of padding down first to protect the body of your lens, otherwise it will quickly take on a second-hand look.

It's certainly worth buying as part of the two-lens kit discussed at the end of this chapter. A lens of up to 300mm can be a real boon to the SLR user.

500mm mirror lens

As you will no doubt have worked out, a 300mm lens is going to be quite a length (300mm plus fixings). And yes, a 1200mm really would be as long as it sounds and would need a tripod all of its own. To bridge the gap between

> A 300mm telephoto lens is probably about as powerful as most people will require

ABOVE **Some telephoto lenses are so large that they demand a tripod all of their own. If you mounted the camera on the tripod the weight of the lens would put too great a strain on the lens mount and could cause damage.**

these, there is a 500mm lens that uses mirrors to bounce the light around to make a shorter lens. By effectively folding the light twice the length of the lens can be reduced to around 170mm. Such a lens is physically very wide (to accommodate the mirrors) and has the disadvantage of a fixed f/8 maximum aperture. The big advantage the mirror lens has over a conventionally designed lens is price. A 500mm mirror lens is a fraction of the price of a conventional design and can fill a place in your camera kit for those occasions when you want to get in really close.

The design also means that manual focus is a necessity, and with the incredibly narrow depth of field that comes with this sort of focal length you will have to be extremely careful if you want sharp results. And if you thought camera shake was an issue with 300mm, 500mm will

introduce you to a whole new world of problems. A monopod is an essential, and a good tripod is even more ideal. Just because the mirror lens is so small, people assume that they will be able to hand-hold it at slower shutter speeds. This is not the case. You are still holding a 500mm lens, and that means an absolute minimum 1/1000 of a second shutter speed. And with an f/8 maximum aperture that is going to be hard to achieve. Unless you have very steady hands, you will have problems just holding the lens steady for focusing and viewing. For serious photographers it is a great accessory to be able to call upon at those moments when you want to get photographs of something you cannot get near, for that special detail in the landscape, but it is not something that the average photographer wants or needs to carry around in their camera bag.

A lens kit for all occasions

Given the quality of today's zoom lenses, and the money-saving offers often available, I would suggest a two-lens kit for general photography. The ideal kit for someone starting out with a 35mm SLR camera consists of a good quality 'standard' zoom of around 28mm–90mm, and a second zoom of around 70mm–300mm. With these two lenses you should be able to approach almost all the usual photographic subjects with confidence. Yet with a single camera body your kit will fit into a sensibly sized gadget bag without weighing you down.

No doubt you will eventually want to add more lenses to your kit. You would not be an SLR photographer if you did not. At the last count my camera drawer held something like seven lenses, and there are still one or two I would like to add to the collection. Yet the two lenses I have referred to above are those that I use the most.

When you buy your camera make sure you ask about any special offers that might be available for a second lens. These offers can often be very generous and get you a complete lens kit in one go. There is a new breed of zoom lens on the market that claims to be a 'superzoom'. These cover huge focal length ranges from around 28mm right through to 300mm all in one lens. While these devices reduce the bulk of your camera kit there is inevitably a

Just because the mirror lens is so small, people assume that they will be able to hand-hold it at slower shutter speeds. This is not the case

degree of compromise in the optics. Nothing great, but at the farther reaches of the zoom range you can be sure that your two-lens kit will provide better results. Not by much, but enough to be noticeable when you start to turn out decent-size enlargements. Only you the photographer can decide whether the smaller gadget bag is ultimately a worthwhile trade-off against image quality.

If you do want to go down the fixed focal length route (and you will be in good company if you do) then the same comments about range of focal lengths still hold good. Your final bill will be higher than with the twin-zoom lens kit, and your gadget bag far heavier. The upside will be that your images will be of a better optical quality which will be appreciated by the dedicated photographer.

Marque or independent?

It is an area of some debate whether it is better to buy lenses made by the camera manufacturer or those made by the independent manufacturers. With the oft-mentioned improvements in modern technology, there is no longer a huge difference between the quality independents and the marque lenses. If you want to try the superzoom market you will be forced to look to the independents as mainstream camera manufacturers have chosen to avoid this area of the market.

If you want good results, I would advise keeping well away from the budget specials found in certain electrical appliance retail outlets who just happen to sell cameras as well. Stick with the well-known names and you should not go far wrong. That said, for some lenses that are not going to be used very often it can sometimes make sense to buy a cheaper version. Something like an ultra wide-angle zoom that has distortion built in as standard might as well come from a cheap stable rather than an expensive manufacturer. After all, if you are buying a lens like this for its distortion, why pay to have it corrected out?

If macro is going to be your thing, then once again it is wise to look to the independents for a lower-priced model. Camera manufacturers are incredibly expensive in this area, so looking to the other makes will save you a small fortune and you can still expect them to be optically excellent.

> '... there is no longer a huge difference between the quality independents and the marque lenses'

LEFT Love it or hate it, the zoomburst effect is here to stay. Set your standard zoom to its widest setting and use a long exposure (around 1/15 of a second). As you press the shutter start to zoom in, and keep zooming after the shutter has closed. This is the effect you get.

RIGHT The tripod banishes camera shake, makes you stop and think before pressing that shutter, and allows long exposures.

Added extras

As already mentioned, the 35mm SLR is the most flexible photographic system available to the hobby photographer. There is a whole world of useful little (and some not so little) devices available to help you produce all kinds of images and to allow you to emulate just about every photograph you have ever seen. The only problem is

that if you chose to purchase every item in this chapter
you would need a sizeable bank balance and a suitcase for a
gadget bag.

While you will no doubt accumulate many of these
accessories over the years, you really do not need to
carry them all with you when you are out and about.
You couldn't. Just pack what you think you are going to
need for each occasion.

The tripod

The tripod is a photographic accessory that can be both a
blessing and a curse. To be a useful aid to the steadiness of
your camera, it will have to be heavy and sturdy. But if you
buy one sturdy enough to banish any chance of camera
shake it will be too heavy to easily carry about with you and
will get left at home. It is worth finding a compromise. Used
properly and regularly, a good tripod will allow the use of
top quality slow films in low light conditions which can
produce enlargements of breathtaking quality.

When buying your tripod go to a shop that stocks a
range of different types so you can try a selection with your
camera. Take your longest lens with you and see how steady
the tripod really is. Some small models really are little more
than glorified camera stands and do not offer real rigidity.
Aim for something in the middle of the range and it should
serve you well. After all, what can go wrong with a tripod?
If you manage to wear one out, then you are using it
enough to justify buying a much better one from a real
specialist. And this time buy one that is good and heavy.
It will serve you well.

If you are wondering what you can do with a tripod in
order that it is worth spending the money, think about all
those lovely night-time scenes of Christmas lights in the
local papers. They were all taken with a tripod as no one
can hold a camera rock steady for the whole time that such
a picture requires. Another classic tripod-only image is of
night-time roads with the vehicles' headlights recording as
long lines of coloured light. Again, this requires a shutter
speed measured in seconds. Far too long for even the
steadiest hand.

Others use their tripods to get the best from their
landscapes; loading the slowest film available and stopping

> The tripod is a
> photographic accessory
> that can be both a blessing
> and a curse

ABOVE **The cable release removes the need for you to touch the camera while taking a picture and reduces any risk of camera shake still further.**

the lens right down to f/22 for maximum depth of field. It doesn't matter what the shutter speed has been reduced to. The photographer knows they will be getting a perfectly sharp image no matter what the weather. They can even add a polarizing filter (see page 83) to saturate the colours and give the sky a real 'summer holiday' look.

The monopod

The monopod is the one-legged brother of the tripod. The camera is mounted on the top of a telescopic pole which the photographer braces against the ground. By leaning on it the photographer's own two legs effectively form the other legs of the tripod and the camera is held much steadier than if hands-on alone were being used.

While the monopod looks pointless to the onlooker, it can allow you to use shutter speeds some two speeds slower than you would expect. It is the ideal device for those places when a tripod is just too bulky to set up, such as at a

football match where you have to move around to follow the action. Or where the powers that be simply prohibit the use of tripods for safety reasons.

The cable release

If you are going to be making use of a tripod, then a cable release should also be on your shopping list. These fit into a socket somewhere on your camera body (they used to screw into the shutter button, but in recent years they have been replaced by electrical types that plug in somewhere on the body of the camera) and allow you to fire your shutter without actually touching your camera. This avoids the slight shake that occurs every time you touch your camera – even when it is on the tripod it will shake a tiny amount – and if you are taking very long exposures you need to ensure that you avoid this.

Cable releases also allow you to lock your shutter open on the 'B' setting for as long as you want to. 'B' stands for Bulb, and is a relic from the days when flash bulbs were the preferred medium of illumination for indoor photography. The photographer used to lock open the shutter in 'bulb' mode, fire the flash bulb, then manually close it. These days it is only really used for low light photography. There will be a lock button of some sort on your cable release that enables you to lock the shutter open for as long as you wish. Anywhere between 10 and 30 seconds might be reasonable for night-time pictures of lights. While anything up to several hours is used for astronomical photography.

LEFT The solid support of a tripod allows you to take pictures like this in very low light and still come away with a sharp image.

Effects filter quick reference guide

Filter type	Effects	Uses
Black and white/yellow	Darkens blue, lightens yellow/orange	Retains detail to a light blue sky which often records as a plain white on a black and white print
Black and white/orange	Stronger darkening of blue, noticeably lighter yellows/oranges	Adds more texture to a blue sky. Reduces the appearance of freckles in portraits
Black and white/red	Blue becomes almost black, skin tones a ghastly white	Gives dramatic dark skys on sunny days. Produces very pale, ghostly skin on human models
Black and white/blue	Blue lighter, reds/oranges paler	Useful for separating subjects of similar tones from a bland background
Black and white/green	Foliage lighter	Produces interesting, slightly ethereal landscapes with unusual tones
81 series (A, B, C)	Straw-coloured filters to give images a 'warm' effect	Adds a tan to a model and can make a dull day look more welcoming
FLD	Colour correction filter to remove green cast by fluorescent lights	Gives the 'right' colours when taking pictures under artificial light sources
80 series	Colour correction filters to remove colour casts produced by artificial tungsten light sources	Gives the 'right' colours when taking pictures under artificial light sources
Diffuser	Soft unfocusing of the highlights	Useful to create unusual landscapes and traditional 'glamour' images
Sepia	Gives a strong brown cast to an image	Designed to make a picture look as if it was taken in 'Victorian' times

BELOW Square filters slot into a special holder screwed into the filter thread of your lens. Square optical resin filters lack the hard-wearing properties of optical glass filters but come in a wider range of types.

soft-focus effect and even artificial sunsets. Coloured filters even have their place in black and white photography; as you will read later, the addition of a coloured filter can completely change the way a picture records on black and white film.

You can buy filters in two forms. The skylight filter on the front of your lens is probably of the optical glass type. These are supplied in threaded metal collars that screw directly into the front of the lens. The other type comes as squares of optical resin. You purchase a special square holder which itself screws into the lens filter thread. You then slide the squares of resin into this holder to put them in front of the lens. These are not quite up to the high optical quality of the glass filters, but they do come considerably cheaper. Many photographers choose to use both these systems.

For filters that get the most use I buy the better quality and harder-wearing glass filters. These include skylight/UV protective filters and a polarizer (more on that one later). For the special effects filters such as warm-up, graduated

and black and white types, I use square optical resin filters, as their slight drop in optical quality and less hard-wearing nature is of less significance. Filters used all the time are likely to get occasionally scratched or knocked. As the glass is more hard-wearing they last longer in general use.

The list of filters I am now going to offer you is far from exhaustive. If I tried to list all the filters on the market I could easily fill this book, so treat this list as a guideline of what is available and a guide to some of the more useful types. If you fall in love with creative filters there are plenty of manufacturers' catalogues and websites out there just waiting for your attention.

Polarizer

The polarizer is unique among filters in that it is made up of two pieces of glass, one fixed, the other able to be turned within its mount. This is the filter you will make extremely heavy use of if you become interested in landscapes. It is this filter that is also used by photographers to produce those larger-than-life blue skies and deeply saturated watercolours that look so welcoming in holiday brochures. Is this a con to lure in the holidaymakers? No, not really. All this filter does is put the brilliant colours back into the photographed scene so that it looks as the naked eye perceives it.

To use it you simply rotate the moveable front element of the filter while watching the effect through the viewfinder. You will see the blue of the sky become more saturated, and the clouds begin to stand out more. As you turn the filter past the peak, you will see the effect begin to pale and soon you will be back where you started. Simply take the picture when the blue you see is as you want it to be, and that is what you should get on film. The only problem might be the film itself, especially if you are using print films.

Some films record the sky in glorious colour, while others seem to give a washed-out rendition. This is due to the large contrast range between the sky and the land. It is often not helped by the processing that the film receives, although this is a problem that is fast fading as processing technology improves. To really get the full effect of a polarizer you need to use slide film. This records colours

ABOVE Optical glass filters screw directly into the filter thread of your lens and are of a superior optical quality to resin filters. The downside is that they cost more.

RIGHT **A classic building against a blue sky. Processing can sometimes leave you feeling that the sky could have been a stronger shade of blue.**

much more faithfully than print film as there is no second step after the processing (from negative to print) to reduce the colour saturation.

The filter works on the same principle as a pair of polarizing sunglasses. Only instead of a fixed amount of polarization, you can vary it to suit your picture with that moveable front element. As with sunglasses, the effect you achieve varies depending on what angle to the sun you are

BELOW **By adding a polarizing filter you can add saturation to skies and water to achieve a more striking colour.**

LEFT Cream stone buildings lit by direct sunlight have a marvellous warm quality. However, this is often lost in the final prints.

standing at. Polarizers cut out reflected glare, so they are also incredibly useful when taking pictures through glass, or even when you want to enhance reflections in a lake.

Warm-up filters

Ever wondered how professionals always make their photographs look like they have been taken in perfect sunny conditions even when up against the vagueries of the

BELOW By using a warm-up filter (81 series) you can put back that typical warmth you expected. Use weaker filters with slide films, and a grade or two stronger with prints. Otherwise the processing house may just filter out the extra warmth at the printing stage thinking it was a mistake.

ABOVE **A boring, featureless landscape often needs a lift.**

weather? Or how their models' suntans always seem to have that extra 'kick'? Such effects are achieved using filters.

The warm-up filters – or the 81 series to give them their technical designation – add a nice summery gloss to any image. They also improve the tan of models and generally give a nice 'lift' to any picture taken in cool lighting conditions. As you might expect from the description, warm-up filters are plain-coloured filters with a light yellow/brown tint to them; 'straw-coloured' is the usual description used.

The 81A is the weakest of the family and will not even be noticeable when using normal print film, while 81C is the strongest and has a really noticeable effect on the final image. There are others in the series (they go all the way up to 81F), but these are aimed at a more specialist market and you will be hard-pressed to find them outside of professional photographic suppliers. They also give an image an artificial look which most hobby photographers seek to avoid.

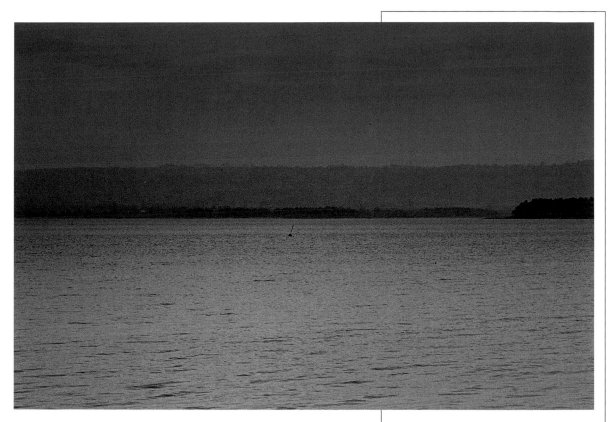

Autumn colours can also benefit from 81 series filters, as can traditional stone buildings and certain coloured plants, so you can see that they are not just for the people photographer. The 81A or B has a place in the kit of almost all photographers. If you use slide film regularly you will find a use for them on nearly every film you take. Used carefully the 81 series filters can add a real sense of life to your images.

Graduated filters

These are always sold in the square format, and at first sight have very little use. They are strongly coloured at one edge, fading gradually to clear resin at the other. While they are available in many colours, only two find regular homes in most gadget bags: grey and sunset.

As noted above, as the sky is so much brighter than the land in most photographs it is often recorded as a pale version of what it was. By using a graduated filter you can reduce this contrast and get a more balanced photograph.

ABOVE **The standard zoom lens of today focuses far closer than similar versions did a few years ago, yet this is still about as close as you can get without additional help.**

Simply fit your graduated grey filter and slide it down in its holder until the faintest traces of the grey can be seen to touch the horizon line. Then take your picture. The grey filter will have evened out the contrast and brightness in the image. If you are out on a cloudy day and you want to add a little drama to your image, push the filter down further so that the more solid black portion is nearly touching the horizon and it will colour your clouds a lovely dark grey.

The sunset graduated filter does exactly the same thing as the grey, only it is a far less subtle orange colour. When used as intended at sunset it can give real substance to weak colours. Unfortunately there was a trend in the heyday of special effects filters for photographers to use them during the day to create artificial sunsets at all sorts of times of day. Done with care, it may surprise you to hear that this can actually work quite well, however it can easily be misused and create very fake results. If you do use a sunset filter, use it carefully and in moderation.

The more brightly coloured graduated filters have two real purposes. Things like red and yellow graduated filters have a place in black and white landscape photography, while others are used purely to add effects to images. The 'graduated tobacco' was one that saw popularity in the 1980s and for a few years exhibitions were flooded with images taken using this filter. Used occasionally they can create interesting and unusual images, but again, are best used in moderation.

ABOVE **By using a close-up filter (a +3 was used here, but they come in strengths from +1 to +10) you can get in far closer and still get good quality results.**

Close-up filters

If you really want to get into serious close-up photography, the ultimate accessory is the genuine macro lens, 90mm or 100mm of optically perfect glass that will produce wonderful results every time. The only problem is that macro lenses are expensive to produce because of all sorts of complicated linkages and pieces of glass needed to get in really close. However, the world of filters has a solution to your problem.

ABOVE **A black and white image of a red car.**

ABOVE **By adding an orange filter, the car now records as a much lighter colour.**

ABOVE **A blue filter delivers a much darker image.**

Enter the humble close-up filter. Best purchased in their screw-in optical glass form, close-up filters come in a range of strengths from +1 to +10. The higher the number, the stronger the lens and the closer you will be able to get to your subject. And all at a fraction of the cost of a macro lens. So what is the downside? Ultimate image quality.

When used with care, the close-up filter can come surprisingly close to matching the quality of a macro lens, though it is important to stress that they must be used carefully. A tripod is crucial, as depth of field at these sorts of distances is very small. So stopping your lens well down (choosing a small aperture) will be essential. This means using a very long shutter speed, which makes hand-holding the camera impossible. If you have a cable release, use this as well in order to keep the camera steady.

Because of the way the close-up lens is designed, you will also have to make use of the manual focus option on your camera (assuming you are using an autofocus model). No great chore when using a tripod of course, but care will be required as there is very little margin for error.

For the best results you need to keep the subject in the very centre of your frame. Fall-off of image quality towards the edges can be pronounced, but once you have centralized your subject and carefully focused on it, then stopped well down, you will get a surprisingly good quality image.

As a general rule a +3 strength lens is a good compromise for general use. Using a +3 with a normal standard zoom should make it possible to fill the frame with your average flower head. The optical distortion is kept to a minimum, yet it offers very worthwhile advantage over the standard lens in close focusing ability.

Black and white filters

It may not be obvious why coloured filters are useful with black and white film when you are actually taking the photographs, but you will certainly see the results when you have had them processed. Black and white film reacts to light in a different way to colour film. When you put a coloured filter onto the lens it lightens anything in the picture the same colour as the filter, and darkens anything of the opposite colour. If you remember any of your physics or art classes from school you will remember the colour

wheel. Every colour has a direct opposite, exactly as you see in a colour negative. As a photographer with a black and white film in the camera, you can make use of this characteristic to produce distinctive images.

The classic palette of filters for black and white use is yellow, orange, red, blue and green. A yellow filter will slightly darken the blue of the sky on a sunny day and make the white clouds stand out more. Orange is basically a stronger version of the same principle and the blue in the sky starts to take on an even more pronounced look. Portrait photographers will find it can reduce the effect of freckles and change the way red hair and blue eyes record on film. Just bear in mind that your models might like themselves with freckles and normal-looking hair, so be careful what you do to their appearance.

A red filter has a very pronounced effect on the way a scene is recorded. Blue skies go very dark, and skin tones a

BELOW By using an orange filter, detail has been recorded in a pale blue sky that would otherwise record as a plain white expanse on the print. Using a red filter would have created a more intense and unreal effect.

RIGHT Coloured filters have their place in studio work as well as in landscapes. This is how a portrait was recorded in straight black and white.

ghostly white. Red cars can be persuaded to reproduce as nearly white, as can red dresses and any red foliage you might encounter. As ever, you either love or hate the effect, but a little experimentation can work wonders.

Landscape users not bothered by the detail in the sky can make great use of the green filter. Foliage and plants will reproduce much lighter than you would expect, and similar shades of green will show up differently on the final print. Green filters are useful for giving those bland green tones a little bit of a lift, and to create a more unusual look.

Blue is the last filter in the traditional kit, and it has no single use. It simply lightens any blue in the image, and

darkens any green. Most commonly used to introduce some degree of contrast between subjects, such as a person in light clothes standing in front of a green bush. With a blue filter the bush will appear much darker on film and make the person stand out.

If you find yourself seduced by the allure of black and white you will find this filter kit being used to the full. Buy the best you can afford and use them well. If black and

LEFT Add a red filter, and the whole tonal range changes. The parts closest in colour to the red of the filter are rendered much lighter (red dress, lipstick, freckles), while the opposite side of the colour wheel is turned much darker (most notably the blue eyes).

ABOVE **Here we have a simple Cotswolds scene that would lend itself to the use of a filter.**

white is not really your thing, just buy a couple of cheap square filters and experiment. You might be surprised at how much you like the results.

Diffusers

Also known as 'soft focus' filters, these are covered with tiny prisms that bleed the highlights of the image into the shadows and give a soft focus effect that is sometimes used to soften portraits or landscapes. Used on a misty morning landscape they can give some truly fascinating results. Once again, a filter is easily overused but worth the effort as it can produce some striking images.

The amount of diffusion varies according to the aperture set on your lens. If you are working with the aperture nearly wide open the effect will be very pronounced and your subject will look as if they are out of focus. But close your lens down to something around f/8 or f/11 and the

LEFT By adding a diffuser the scene takes on a light, misty quality.

effect is much reduced. There should be just a subtle hint of the soft focus effect, and the delicate bleeding of the highlights to give the image an other-worldly look. Use it carefully and sparingly and this is a very handy filter to have to hand.

BELOW Or if you prefer, you can shoot through a sepia-effect filter to give the impression of an earlier time.

ABOVE Add some life to your static night-time exposures by using a starburst filter. These will turn any bright point of light into a star and come with varying numbers of points.

Cross-screen filter

Purely for use when taking pictures at night, this filter produces a 'star' pattern over any point of light that appears in your photograph. Be it car headlight, street lamp, lighted candle or festive lights, the pattern of regular lines etched into this filter will turn them all into artistic stars of light. Of limited use in general circumstances, it can be essential for those two or three months of the year when you can take up your tripod and take photographs at night.

Colour correction filters

A boring set of filters to finish the itemized listing, but a set essential to any serious photographer in order to correct variations in different types of light. Your colour film is what is usually referred to as 'daylight-balanced'. That is to say, when you take pictures under normal daylight, the colours render normally. But if you take pictures under artificial light, things start to go wrong. Normal domestic light bulbs give off a very brown light. This can give a

LEFT A colour correction filter would have changed these charming Christmas lights back to their correct white colour. But this is one of those times when the warm glow of tungsten lights made the picture more interesting and the filter was left in the bag.

comforting look to indoor pictures taken on print film where much of the colour cast is filtered out at the printing stage. But if slide film is your chosen medium, your images will look painfully brown and unattractive. To counter this problem you need one of the 80 series filters. Which are exactly like the 81 series warm-up filters already discussed, only instead of warming up the image, they are blue and therefore cool it down.

Fluorescent light will need a magenta filter (technical term FL-D, or fluorescent to daylight) to do away with most of the colour cast. Professionals who have to do away with

ABOVE A simple flower portrait, taken without the addition of a filter.

BELOW The clear-spot picture keeps the flower clear, while surrounding it with a coloured mist.

all of the colour cast, will have problems as there are several kinds of fluorescent light out there. They use a colour temperature meter and a very expensive set of filters to get things exactly right. Amateur photographers will have no need for such a device, but may feel the need for one as their photography progresses.

Unusual filters

There is a huge range of weird and wonderful filters available. They may or may not be of use, and it is always better to start by learning basic techniques before moving on to more outlandish gadgets, but some of them may be of interest in the future. These are just a few of them.

For effects that make your subjects look as if you are peering through a keyhole at them, you can get blank sheets of black plastic that fit into your square filter holder. There are centre-spot filters that colour the whole of the outer edges of your image yet leave the centre clear so it looks like they are standing in a radioactive cloud. There are sepia filters to make your subject look as if they were photographed back in the days of Queen Victoria. There are even clear filters supplied with little bottles of dye so you can make your own grossly overcoloured filters. There is even the multi-image filter that surrounds the central subject matter in your picture with several more examples through the use of simple prisms.

No matter how much you try to avoid them, all photographers end up with a little pile of filters somewhere in their kit. I would suggest that filters should be used in moderation and kept for very specific effects and occasions.

Teleconverters

Super-long telephoto lenses are expensive. Any conventional telephoto lens over 300mm is going to cost you serious money, and you will probably not get much use out of it as it will be too heavy to carry and too tricky to use. So what can you do on those rare occasions that you want that bit of extra telephoto power without breaking the bank? Enter the teleconverter.

The teleconverter fits between the camera body and the lens. By the use of some cunning optical tricks, it effectively doubles the focal length of your lens. It is also small,

relatively cheap, and fits neatly into your gadget bag. As ever, there is a downside to this handy little gadget. Image quality suffers quite badly when buying at the cheaper end of the market, so be prepared to pay good money for one from a well-known manufacturer. They also absorb light. The 1.4X teleconverter (which adds 40% to your focal length) takes 1 stop of light, while a 2X teleconverter (which effectively doubles the focal length) absorbs 2 stops of light. Bearing in mind the problems with camera shake and shutter speeds associated with telephoto lenses, this can cause you problems. Fast film is an absolute must when

ABOVE A display of flowers taken without a filter.

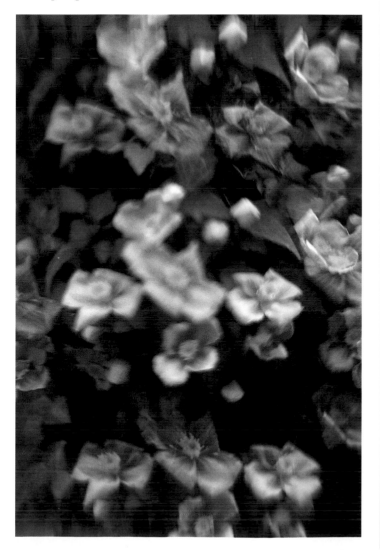

LEFT Add a multi-image filter and you get a repetition of the flowers around the original. The sheer thickness of the filter adds a certain softness to the image, which can add to its charm, though can easily be overdone.

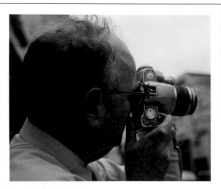

ABOVE **The modern SLR camera with its standard zoom lens is a compact package suitable for most uses.**

ABOVE **The fish-eye adaptor adds considerably to its bulk and length.**

using a teleconverter, and a tripod is advisable. But even under these circumstances, with your teleconverter on your 300mm lens, you should at least come away with a decent picture if you take some care.

Fish-eye adaptor

Much like the teleconverter discussed above, the fish-eye adaptor alters the focal length of your lens. This device screws into the filter thread on the front of your lens and drastically reduces the focal length. The distortion you achieve is exactly as if you were using a fish-eye lens. The only real difference is the size of the hole in your wallet. The optical quality naturally leaves a lot to be desired over the more expensive option, but as photographers expect distortion from a fish-eye lens it is far less noticeable than with a teleconverter. And it gives you a chance to try the curved world of the fish-eye lens for a tiny fraction of the price of a proper fish-eye lens.

Gadget bags

It's a good idea to have at least one bag. One should be big enough to carry your whole camera kit, then another for a more basic kit of the body and just your two lenses. And maybe a third one for just the camera with its standard zoom lens. There will always be a need for a bag to fit the requirements of a specific day.

If you find yourself becoming heavily involved in your photography, buying a really cheap bag is a false economy. Decide what sort of camera kit you carry most and spend good money on a quality bag. Remember to choose one that gives the option of carrying plenty of film, as well as everyday items that you need to keep to hand.

It is a sad fact of life that camera bags that suggest that their contents are expensive are now an inadvisable investment in many places. Buy something discrete. Something that will pass for an everyday shoulder bag as you carry it about is ideal. If you must buy something from your camera manufacturer with their badge emblazoned across the front, find a way to tone it down. Perhaps with a little dye, or consider removing the badge entirely.

This chapter could go on for pages and pages, listing every conceivable gadget for the photographer. This would

give the impression that you need all sorts of these bits to be a good photographer and get the best out of your 35mm SLR. In fact you do not need any (and I do mean any) of the bits listed in this chapter to take good photographs. Many would argue that you are better off not having any of these accessories. They do, however, allow you to make your pictures look that little bit different. My advice would be to invest in a basic filter system and perhaps buy one or two chosen accessories to inspire yourself with.

ABOVE Get in really close with a fish-eye adaptor for some interesting effects. And watch out that you don't capture a reflection of yourself on shiny surfaces.

LEFT Or make the best of the exaggerated perspective to create simpler, but still striking pictures.

In recent years the 35mm SLR camera has followed the trend set by compact cameras and fitted integral flashes. Though low-powered, these flashes can be effective when taking pictures of small groups.

Using flash

There comes a time in every photographer's life when loading a faster film just will not do the job. It may be that the light levels have dropped to the stage where there is simply not enough light around to take photographs, or your shutter speed has dropped to the point where taking pictures of a group of friends at a party is impossible without reducing them to faceless blurs. In situations like this you will need to be able to use a flash.

Many SLR cameras come with a pop-up flash built in. A very basic, low-powered flash that is ideal for taking pictures of small groups. It is exactly as you would expect to find on a compact camera, but with your SLR camera the flash can be much more. Almost all 35mm SLR cameras have an accessory shoe on top of their mirror housing. This is designed to take a separate flashgun. These devices can put out far more light than the camera's basic built-in flash and with the right model it will do away with all the complicated calculations you once had to make to get the exposure right in your flash pictures. They also do away with the rapid camera battery drain associated with the extensive use of built-in camera flashes.

Flashguns come in three types: manual, automatic and dedicated. They may all look the same on the shelf of the camera shop, but they are very different. Generally, the more you pay the more features you get to play with and therefore the easier your flash photography will become.

LEFT All 35mm SLR cameras come with a flash shoe on top of the mirror prism for the mounting of a more powerful and sophisticated flashgun. These larger units also have their own power supply, saving the drain on your camera's batteries.

BELOW The manual flashgun is the cheapest and simplest available. It fires a fixed amount of light every time it is triggered and you the photographer have to set the f-stop of your lens to suit this output according to the distance the subject is away from your camera and a table usually printed on the rear of the flashgun.

Manual flash

These are the most basic, simple and cheap of all the flashguns available. They are also the last resort and in this day and age they are probably best avoided. They operate on the simplest of principles; you put in the batteries, the flash charges up, and when you press your shutter button the whole of the capacitor's charge (the part that actually powers the flash) goes through the flash tube and a fixed-size flash results. It is up to you to set the right aperture on your camera according to a table supplied with the flash (and often printed on the back of the unit as a handy reference) and to set the right shutter speed on your camera. With some modern SLR cameras this process can be a real chore.

RIGHT The flash shoe has undergone a transformation in recent years. The large centre pin fires all flashguns, while the smaller pins allow a dedicated flash to talk to the camera's own metering systems and give you a far more accurate result.

The aperture will depend on the distance of the subject from the camera; you must get this right or your exposure will be wrong. The easiest way to do this is to read the focusing distance off the barrel of your lens. The snag with this is that it does away with any sense of spontaneity in your pictures. For this you will need something a little more advanced.

Automatic flash

These look very much like manual flashes, except that they tend to be larger. They also tend to be more powerful. You mount them on your accessory shoe just like a manual flashgun, but there is one big difference. If you look at the front of the flashgun you should find a small hole. Probably no more than a couple of millimetres across. This houses the all-important metering cell.

The controls will probably present you with two or three settings with an automatic gun, each of which covers a set distance range. Choose the setting you desire (for example, f/8 might cover the whole distance from two to five metres) and once you have set that aperture and the correct shutter speed for flash use, the flashgun is ready to go. That little metering cell does everything else for you. It measures the light falling on the subject and fires enough light to illuminate the subject. It then cuts the power to the flash to save battery power. If half of the capacitor's power is used, it only has to recharge back up to full power. It does not use all its power like the manual gun. If you do a lot of flash photography, this can save you quite a lot of battery money.

> That little metering cell does everything else for you

Dedicated flash

If budget permits, a dedicated flashgun is the way to go. Invariably more expensive than the other types of flash listed above, it offers you all sorts of useful benefits.

If you look at the flash shoe on top of your camera you will see a number of electrical contacts. The big central contact is common to nearly all SLR cameras and is used to fire the more basic types of flashgun and is what makes this a hotshoe. The other, smaller pins allow the dedicated flashguns to communicate with the camera's metering systems. All you have to do is slip a dedicated flashgun into

LEFT The rear panel of a modern dedicated flashgun displays all sorts of information, including the focal length you have set on your zoom. Leave it alone and it will do all the tricky calculations for you.

ABOVE AND BELOW **The output of a flashgun is very brief, and it has the effect of freezing movement, as these pictures show.**

your hotshoe and turn it on. The camera will now automatically set the right shutter speed and aperture so that you do not have to make these decisions yourself. The flash output will be measured by the camera through the lens metering system, right off the film itself using the complex multi-zone metering gadgets that improve your daylight images.

Many dedicated units also feature a strange red bulge on their front. This is a neat feature for autofocus SLR cameras alone. In the event of there being very little light it allows the camera to have the flashgun fire a beam of infra-red light to allow it to focus in near total darkness. Then the flash can fire in the regular way and take the photograph.

If you take pictures out of doors and you want to highlight a subject or make use of fill-in flash in bright sunlight (more of this later in the chapter) the camera will work it all out for you. The days of head scratching and calculators are all behind us with the dedicated flashgun. Some devices even offer strobe, slow-sync and adjustable output flash. Far more than you might think you need now, but in a few months time, who knows.

Using your flash

Your camera shutter has what is technically known as a flash sync speed. This is the fastest shutter speed you can use and still use the flash, and can be anywhere between 1/30 and 1/250 of a second depending on your camera. If the shutter is not open for at least the given sync speed the flash will not have time to illuminate the subject before the shutter closes. It may not look like it, but the light from the flash tube takes a moment to build, and for the camera's light meter to react and shut off the flash when the exposure is done.

If you set a speed higher than the official sync speed (this will be given in the camera's manual, and is sometimes referred to as the X-sync speed) your image will have a hard black line across it. This is because the shutter was already closing when the flash illumination reached its peak. So make sure you set the right shutter speed if you are using a non-dedicated flashgun. A dedicated unit should set the shutter speed for you without you having to do anything beyond turning on the flash and slipping it into the hotshoe.

> Because the flash provides most of the illumination, it effectively freezes any movement in the image

LEFT **If you set the wrong flash sync speed on your camera, the shutter will move too fast for the flash output, and parts of your image will be obscured by the moving shutter blinds.**

Due to the nature of flash photography, it does not matter if you choose to set a slower shutter speed than the sync speed. Because the flash provides most of the illumination, it effectively freezes any movement in the image. There are times when you will want a longer shutter speed for creative purposes – we will take a look at them later in the chapter.

You need to set the correct aperture to obtain the correct exposure, exactly like normal daylight photography. With the manual flashgun the aperture will be dictated by the distance between the camera and the subject. There is usually a helpful table on the rear of the flash itself that

ABOVE Direct flash is the most power-efficient, but it gives bleached-out colours and harsh, unforgiving shadows.

RIGHT By diffusing your flash (either by bouncing or by fitting a diffusing device) you create a much softer and more flattering light.

cross-references film speed against distance to tell you the correct f-stop to select. On automatic guns you have things easier as all you have to do is set the aperture for a set range of distances and let the flashgun do the rest. Once again, the dedicated gun should get the camera to make all these settings for you. The only problem with mounting your flash on the top of your camera is that, while it is convenient, it is just about the worst place to put it if you want flattering

pictures of your family and friends. The light is direct and can bleach out the detail on people's faces as well as enhancing any instances of florid complexions.

The reason that pictures taken with direct flash are so unflattering is because the flash is such a small point of light firing directly at the subject. To eliminate this problem you need to change the direction of the light and make its source larger. The trick is to bounce the flash off a large surface such as a wall or ceiling.

The better flashguns (which usually means the manufacturer's dedicated units and some of the more expensive independents) offer you a facility to turn the flash upwards and sideways while still keeping their sensors towards the subject. By pointing the flash towards the ceiling you are spreading the area of light over the whole ceiling, and, as it is now coming downwards onto your subject, there is some modelling to relieve the harshness of the light.

Flashes from the upper end of the market can be swivelled and tilted. To get the most flattering results from your flash, tilt it up at around 45° and across at a nearby wall on a similar angle. This will give you a flattering light and will add texture to your subject.

If you are out in the open (see Fill-in flash below) you can achieve a very similar effect by slipping an opaque plastic diffuser over the flash head to make the light softer and less directional. As long as the metering cell is still pointing at your subject, the exposure will still be spot on.

> ' The reason that pictures taken with direct flash are so unflattering is because the flash is such a small point of light firing directly at the subject '

LEFT Using the flash at night to create a fixed central point and then zooming with a longer shutter speed can create a subtly different result to the zoomburst effect looked at in Chapter 5.

ABOVE **Natural lighting can sometimes mean people and things are in shadow, with their finer details obscured.**

RIGHT **By using your flash outside you can fill in these shadows to create a better picture. No huge amount of flash is required, so your on-camera flash is fine for this purpose. Most modern cameras and dedicated flashguns have a specific setting for fill-in flash that takes much of the guesswork out of the technique.**

Special effects

If you thought your hot shoe mounted flash was just for taking pictures when there was not enough light, think again. By adding a flash to your camera you have opened up a whole new world of photographic techniques.

Fill-in flash

When taking photographs against a strong light such as a bright sky, your meter will decide the whole image is brighter than it actually is and expose for the bright background rather than your intended subject matter.

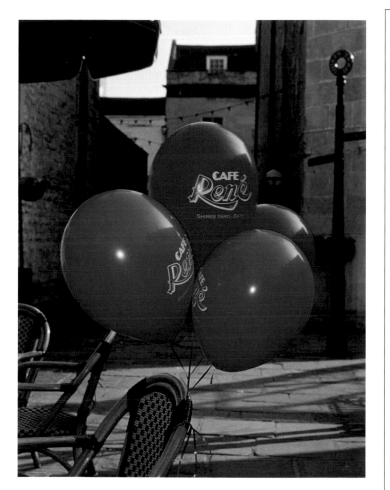

The person or subject in front of the brighter light source will be rendered as a silhouette. You can get around this by using a fill-in flash.

If you are using a dedicated flashgun, there will probably be a setting for fill-in flash. The principle is simple. The camera's onboard metering computer continues to expose for the background, while the flash puts out a small burst of flash to 'fill in' the shadows. In a perfect world the two sources of light will be perfectly balanced and you will not be able to tell that flash has been used.

More usually, the effect of the flash is noticeable to any keen photographer who looks at the image. Other people just tend to notice that there is something not quite right about the image. The use of a diffuser as discussed above can reduce this slightly unnatural look, and with the

> If you are using a dedicated flashgun, there will probably be a setting for fill-in flash

111

RIGHT The metering system on most SLR/flash combinations is designed to expose what it thinks is the main subject correctly and to allow the background to take care of itself. In most cases this works just fine, but in situations like this it leads to a bleached-out, harshly lit foreground subject and very little detail in the background.

BELOW By forcing the shutter to remain open for longer using the slow-sync technique, more detail is recorded in the background by the ambient light to create a more natural-looking picture.

addition of an 81 series filter even a keen photographer will be hard-pressed to spot the use of fill-in flash.

If you are using an automatic rather than a dedicated flashgun slightly different advice applies. As your flash is not metering off the film plane of the camera you need to find a

way to fool it into giving out less light than it thinks it should. This should then be balanced with the daylight to give you natural-looking results. While you can expect to have to experiment depending on the make of flashgun and your personal requirements, the simplest method is to set the wrong film speed on the flashgun. The fill-in flash should be about two f-stops worth of light less than the natural light you are trying to fill in against, such as 400 ISO rather than the actual 100 ISO film you have in your camera.

If you only have a manual flash you will need to experiment to work out the best setting. You cannot alter the flash output, so you can either juggle the aperture on the camera, or create some sort of diffuser that blocks out a portion of the light to get the balance you desire. Alternatively, think about buying an automatic flashgun. They are not that expensive, and you will be thankful every time you use it afterwards.

Slow-sync flash

The basic principles of this are very simple. The aim is to expose your subject perfectly without the background falling into darkness. This will require the use of a steady hand or possibly even a tripod. Set a much slower speed than the usual sync speed, for example 1/30 of a second. The flash will fire as normal and the person in the foreground will be perfectly exposed as per your requirements, but instead of the shutter snapping closed after the flash is fired, it remains

ABOVE Most modern film is balanced for daylight temperatures. Domestic light bulbs give out a far more yellow/brown light, causing a white sheet to record as this brown colour. Flash gives out a pure daylight balanced light that counteracts this, doing away with the need for using a colour-correction filter.

LEFT This outdoor night picture shows all sorts of colour casts caused by using daylight-balanced film with artificial light sources. The sodium/ fluorescent lighting of the building has recorded green, while the street lights and the building's internal lights have been recorded as a warm yellow/brown tone.

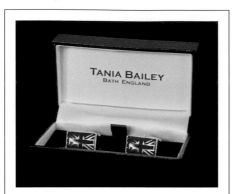

ABOVE Studio lights are useful for all sorts of still-life studies. Here, the bright colours stand out against the plain black background to create a focal point for the viewer.

ABOVE The movement-freezing abilities of flash can capture examples of movement that might normally go unnoticed.

open for a time, allowing the natural light to record some detail in the background. It will not be a perfect record of the background as the colour balance will probably be a little 'off', and you will need to take care with the slow shutter speed as anything moving will record as a blur.

Studio flash

If you want to get professional-looking results, you will need to move away from your hotshoe mounted flash and invest in some studio flash units. Studio flash units are mains powered and mounted on independent stands very much like lightweight versions of your camera tripod. Every time they fire they produce exactly the same amount of light so you will need to set the camera to the requirements of the flash, but there are major benefits to using studio flash.

As they are mains powered their recharging time between shots is measured in seconds. They also offer modelling lights. This does away with one of the major drawbacks of using flash – that you never know exactly how your picture is going to come out until you get your processed film back. With studio flash you have a bulb built into the flash head that illuminates the subject in the same way as the flash head itself. This gives a very close approximation of how your final picture will look. Ugly shadows should be a thing of the past if you work carefully. And with studio flash, there is no excuse not to.

Backgrounds can also be carefully chosen to make the best of your subject. Plain backgrounds for complicated subjects or portraits, and more complex backgrounds that are a more intrinsic part of the image as a whole. Plain walls are a starting point, and cloth screens are widely used by professional photographers.

Once you have got your lights set up, you normally diffuse them in some way so that the light is more flattering. If you use the flash heads direct you will end up with a result not unlike that which you got from using direct flash with your on-camera flashgun. The most commonly used diffusing device is the umbrella, which transforms the small, harsh flashlight into a light source some 24cm (18in) across and softens it considerably. They also come in a wide range of colours. White brollies give the softest and cleanest light, while gold ones add a nice tan if you are photographing

ABOVE Unusual portraits can make use of the motion-freezing properties of studio flash.

people. Silver comes somewhere between the two. Not quite as soft as the white brolly, it offers the light quality of the metallic gold brolly without the colour change. If you can only afford one set of brollies, go for silver. You can happily use them for still life as well as people, and you can always slip an 81 series filter over your lens if you want to give your model a suntan.

There is also a whole world of other ways to control the light from your studio flash. These include soft boxes, barn doors, snoots, snoods and gobos. All of these have their place in studio photography, but they tend to only be available for professional studio systems and are rather outside the scope of this book. Learn the basics of studio flash before making life more difficult for yourself by making things more complicated than they need to be. You can always buy other things as you find a need for them, but there is little more irritating than finding you have spent

RIGHT **In the studio you can control everything, including the background. So while you can be sure you will not have anything growing out of someone's head, you do have to think about what you are doing. Photographing a model in a black dress against a black background is not a good move.**

good money on parts you never use. The light from studio flash units has to be measured with a proper flash meter. These are not especially cheap, but they really are essential if you want to get your studio flash exposures right. There is a huge range of lighting accessories for studio flash, and it is almost impossible to calculate the right exposure on paper the way you do with manual flash. The flash meter is designed to measure the brief pulse of flashlight from the studio flashes and give you an answer in f-stops for your lens. All you have to do then is set this on your camera, and you are ready to start taking photographs.

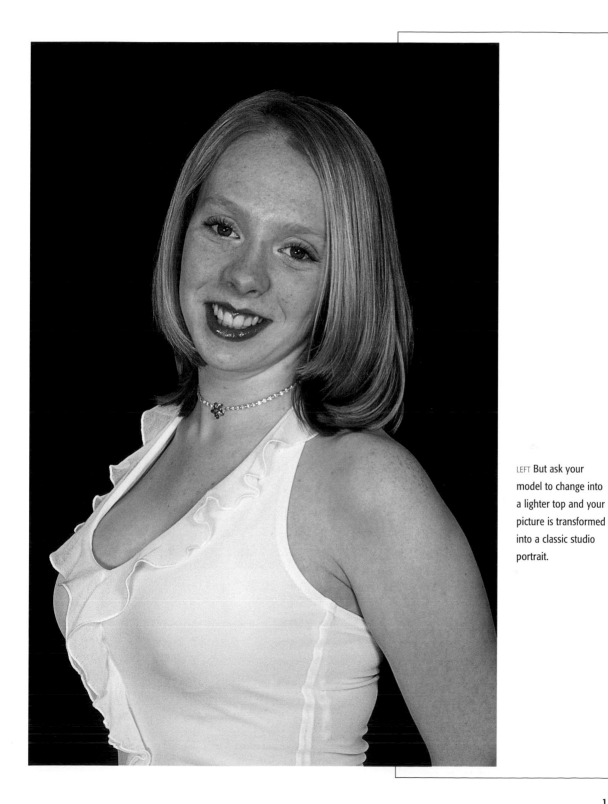

LEFT But ask your
model to change into
a lighter top and your
picture is transformed
into a classic studio
portrait.

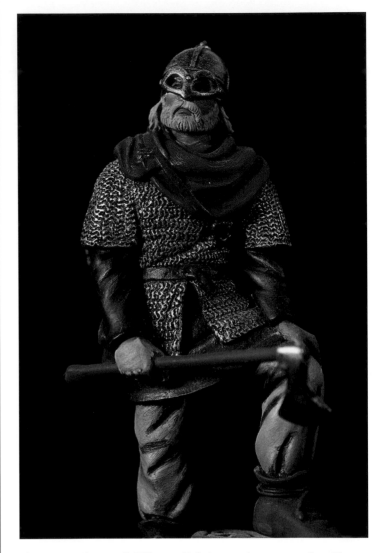

RIGHT **While a plain background is perfect for showing lots of detail in an intricate subject.**

There are plenty of different lighting set-ups to try, but if you only have one light, a good set-up to start with is to place it so the light comes over your right shoulder. It may not be the most creative place in the world to put it, but it will produce decent portraits that will keep your sitters happy.

Diffuse the light with the brolly of your choice, and to fill in the shadows on the opposite side of your sitter place some form of reflector propped up against any domestic chair. Your reflector does not have to be anything professional – white board will do, as will a large sheet of polystyrene packing material. If you find yourself doing a lot

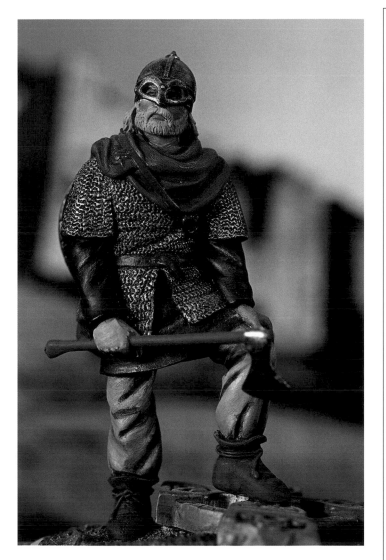

LEFT With a little thought the background can actually be made part of the subject itself.

of studio work, consider covering a large sheet of board with cooking foil for a stronger effect.

If your budget runs to two studio flash units, position one in the same way as suggested above, then put the second at waist height on your left. With the use of a white brolly this will fill in the shadows far better than the white board method and give your portraits more 'life'. Once you master some of the techniques of flash photography you will never look back. Even your outdoor photographs will benefit from your dedicated flashgun and diffuser, and your party pictures will know no equals.

The classic subjects

Ever since the arrival of popular home photography with the introduction of the Kodak Box Brownie in 1900, there have been subjects that are popularly tackled. In this chapter we will look at some of these classic subjects and the best way to approach them. Do bear in mind that there are always dozens of ways of tackling any given subject. The dedicated artistic photographer might choose to totally ignore everything I have to say about any subject and go their own way. I wish them good luck in their search for that elusive thing – the perfect photograph.

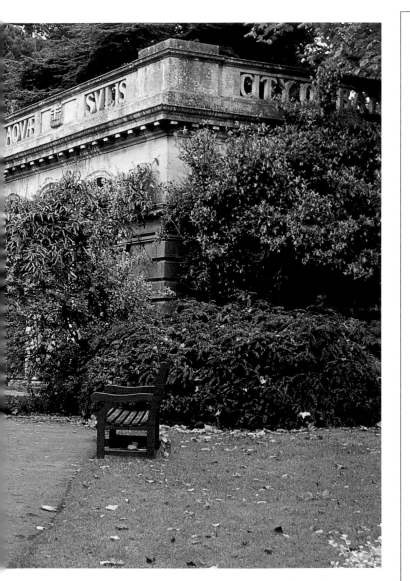

LEFT The much quoted 'rule of thirds' has been applied here, the main subject standing a little to one side of the picture, and a pathway drawing the viewer's eyes into the photograph.

...take that first picture no matter what

The methods I suggest are ones that will produce pleasing images well suited to the frame and the photograph album. And if you followed everything I have written in this chapter, you would probably be a far better photographer than me. There is only one commandment that holds good for every subject, and that is take that first picture no matter what. When you arrive at the top of the mountain, see that exquisite dog, or your model smiles for the first time, take a picture. Alongside all the equipment you have bought, film is very cheap, so grab that first picture before anything has

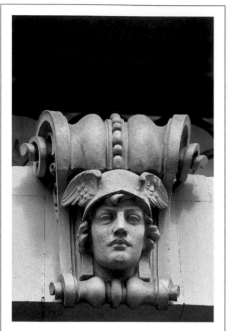

ABOVE Enhance the shadows on stonework with the use of a polarizing filter.

ABOVE Using your tripod and cable release allows you to create night-time landscapes like this. Moving objects such as car lights are recorded as long lines when the shutter is kept open for this long.

ABOVE If you have to take your landscapes on a cloudy day, consider using an 81 series warm-up filter to put a little warmth back into your picture. Here, it has brought some life back to the traditional stone buildings, and the long shutter speed has led the water to record as a soft mass.

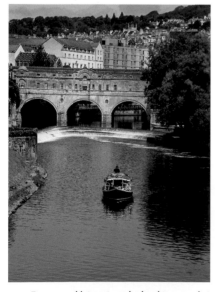

ABOVE Foreground interest can be hard to come by, but this tour boat fulfils that role perfectly

time to change. Then start thinking about how to make it better; whether the light is hitting the model right or how well the background works. In the first instance, it doesn't matter if there is something brightly coloured and distracting in the background, or that you cannot quite frame the person as you would like. Once the moment has passed you

LEFT The concept of something to lead the eye into a scene is shown very straightforwardly here.

RIGHT Keep your eye open for distinctive modern buildings like this for interesting photographs. The reflections on the water add to the effect of a cool, almost monochromatic image.

might not be able to recapture it. So always take that first picture, then try for a better one second time around. You can afford that second frame of film, and in time you will probably find subjects on which you will expend whole rolls trying to get one perfect image. So take first and think later!

ABOVE **Modern glass office blocks that reflect a blue sky, taken through a polarizer, have become something of a cliché, but can still be an effective shot. Use your polarizing filter to its maximum effect and try to crop out all distracting details to create an imposing composition.**

LEFT **If you cannot get to a good vantage point, make sure there is plenty going on in your picture to keep the viewer interested.**

ABOVE Don't be afraid to get in close with your widest-angle lens to make something big of the foreground detail and to turn your landscape into something a little unconventional with all that depth of field you have to play with.

Landscapes

Landscapes are far and away the most popular subject for photographers, yet they are often unsatisfying when you get them back from the processors. This is mainly due to the selective way in which we view scenes when we are actually experiencing them first hand. You might see the mighty peak of Mount Kilimanjaro towering over the plains. What your camera sees is what is actually there when you are standing miles away: a peak in a line of hills with miles of boring level ground in front of it. Which brings us back to one of the basic rules we talked about way back in Chapter 3. Filling the frame with the subject. OK, so it may not be possible to get any closer to the landmark of your choice, but you can get your camera closer by zooming to a more telephoto setting on your lens (a higher number of

Do not limit yourself to just one shooting position. Move around the subject of your landscape and make the best of all the different views, lenses and filters you have in your bag.

ABOVE **Patterns in the landscape look even better when they have been slightly compressed by the action of your telephoto lens.**

millimetres), or even changing to your telephoto lens. Just because common theory tells you that using a wide-angle lens to get more in is the conventional thing to do, it can also make for very boring photographs. It is worth keeping a 70–300mm zoom to hand, even for holiday snaps.

Landscape images also require the most depth of field you can obtain from your camera. If you are still using the subject-specific programs on your camera, the landscape program will bias the exposure towards depth of field over shutter speed. Or a higher f-number (f/11 or f/16, which is a smaller hole and therefore gives more depth of field) at the expense of a fast shutter speed to keep the camera steady (perhaps 1/60 or even 1/30 of a second).

If you want the ultimate depth of field, you might consider using one of the manual overrides on your camera. These controls are aimed at the more advanced amateur. They are still located on the command dial, and are usually identified by the letters A, S and M. The A stands for aperture priority, S denotes shutter priority, and M is for

ABOVE AND LEFT **Water** and reflections work well within a landscape, effectively giving you two landscapes for the price of one.

RIGHT Little details work well to convey the 'flavour' of a place. This frozen bucket captures the coldness of the day.

BELOW Make free use of your polarizing filter when out and about. By increasing the saturation in the blue of this water you will make the white swans stand out from their background.

manual. In aperture priority mode you manually set the lens aperture (either via a dial on the camera body or a ring on the lens depending on the make of camera) and the internal metering system sorts out the right shutter speed. Shutter priority is the exact opposite in that you set the shutter speed and the camera then chooses an aperture to suit.

LEFT Details of a place can work well
alongside more general pictures.

Finally, in fully manual mode you set both variables for very specific situations, although instances when this is required are rare; modern technology has come to the stage where A and S will cover all your major needs.

So, following the theory that for the finest landscapes you require the deepest depth of field possible, you can cheerfully select the A setting on your command dial and close the lens down as far as it will go. The camera will set a shutter speed it considers suitable to obtain the correct exposure. The only snag with this theory is that this approach can lead to very slow shutter speeds. Speeds that you cannot easily hand-hold. This is a regular problem for

ABOVE Rivers and other bodies of water always look good under a blue sky, especially if their colours are enhanced by the use of a polarizing filter.

dedicated landscape photographers, and there is an excellent if inconvenient solution: a sturdy tripod. This will keep the camera steady no matter how slow the shutter speed may be. However the size of a good tripod makes them inconvenient and the lighter models are not worth using. Instead, try resting your camera on something solid. Make yourself a beanbag and use this to support your camera as you rest it on a wall, or the top of your parked car. While these are not ideal solutions and lack the sheer solidity of a good tripod, they are far better than simply holding the camera.

In earlier chapters I have talked about the importance of foreground interest and of having some feature to lead the viewer's eye into the photograph, and it is important to remember that the depth of field must be adequate to make the best of them. A blurred foreground feature is probably worse than not having one at all. Some cameras are equipped with a depth of field preview button. When you look through the lens on your camera, you can actually see the effect you are getting if you can persuade the aperture to

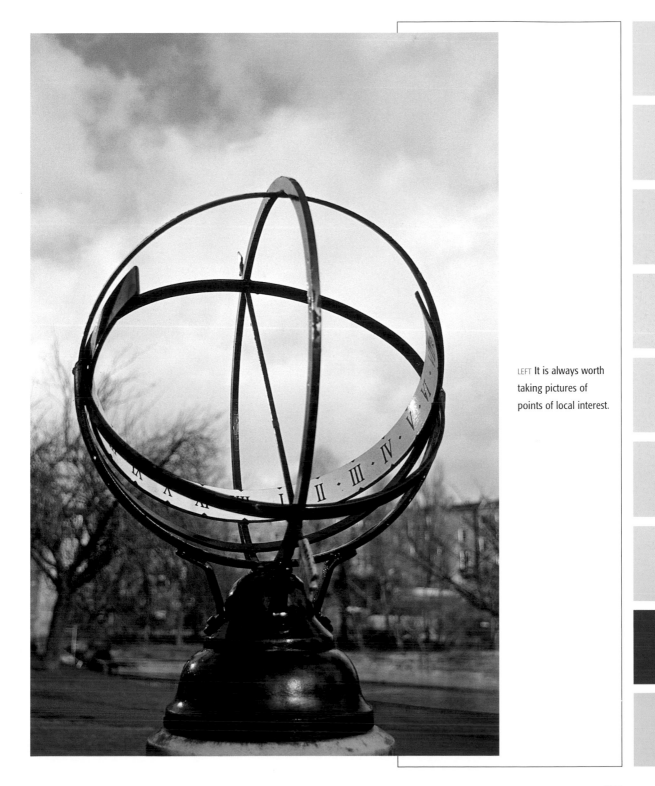

LEFT **It is always worth taking pictures of points of local interest.**

RIGHT **Try experimenting with more abstract compositions. This one works in black and white as well as colour, fulfils the rule of thirds, has foreground detail and something to lead the eye into the picture.**

Get in close to the building with an ultra wide-angle lens and the results will be even more striking

close down as it would during the actual taking of the picture. This is what the depth of field preview does. When you press the button the viewfinder seems to go dark. This is because the aperture is now closed down and what you see in focus is what will be in focus when you actually take the picture. A simple and useful device, but one that the manufacturers often decline to fit on the cheaper models in their ranges.

Once everything is in focus it is time to think about making the best of your image. Is the sky a nice vivid blue, or does the ocean look really nice and deep? To keep this saturated look you may need to fit a polarizing filter (as discussed in Chapter 6). Turn the outer element of this filter until the blue of the sky or the water is at its most saturated, and then press the shutter button. With the right film, your pictures should now come out as you remember them, not as they normally come back from the processors – with slightly washed-out colours.

If there is a really bright sky, think about fitting a graduated grey filter. This will even out the brightness in your image and retain detail in both sky and land if the lighting is extreme. Don't forget that urban landscapes play their part in modern photography. Much of what was said above still applies, and the use of a polarizing filter combined with a modern glass-walled office block against a strong blue sky can create a stunning image. Get in close to the building with an ultra-wideangle lens and the results will be even more striking.

ABOVE Small details can sometimes be picked out more effectively in black and white. Using a red or orange filter can help retain detail in blue skies that might otherwise only record as a plain white expanse.

If you are using colour film (although don't rule out using black and white film for gritty images of urban areas) try to avoid brightly coloured road signs and clothing. Unless that is what you are photographing of course, in which case it is fine to load up with the most saturated colour film you can find. Both are a fact of life for the landscape photographer, both in and out of towns, and the only cure is to get to places as early as possible, ideally as the sun comes up if you are going to photograph a major tourist attraction. Even then you may have to do some careful framing in order to avoid unwanted elements of a scene such as local council workers in their fluorescent jackets.

And don't forget the little details that are often lost when framing for the 'bigger picture'. Little pieces of park furniture, architectural patterns or qualities of light that capture the spirit of the place visited more than the overall

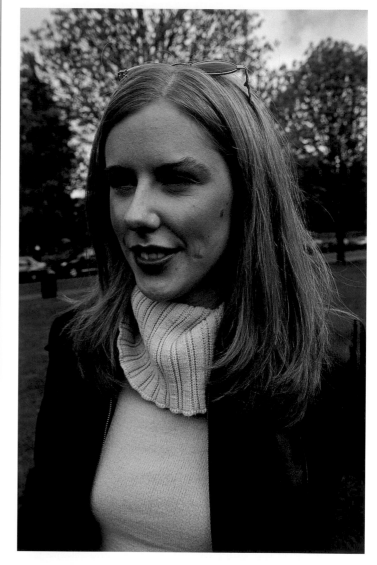

RIGHT Using a short focal length when filling the frame with your subject can cause unpleasant distortion, as seen here with the use of a 28mm lens for a portrait.

scene itself. Pictures that will make your viewers think rather than just presenting them with the more typical holiday scenes. Aside from that, just frame carefully to avoid any unwanted distractions and make the best of what you have in front of you.

People and portraits

People and portraits are probably the next most commonly taken subject after landscapes. Whether they be snaps of people and animals, or properly set up studio sessions, your

LEFT Zoom out to somewhere between 85 and 120mm and you will get a result like this. Far less distortion, and a more flattering result as you are now standing several paces away, about an arm's length.

RIGHT The classic studio portrait. Take one model, add a prop and fill the frame with your subject under two studio lights.

ability with your portraits can make or break your reputation as a photographer. Any person can be made to look natural and relaxed in a photograph and it is the ability to capture this and something of your subject's character that makes a successful portrait once you have got the technical side right.

Most cameras come with a portrait mode on their command dial, and this will be perfectly adequate for outside work. It provides a small amount of bias towards a wider aperture to give a smaller depth of field, so if your main subject is in sharp focus, the background will be largely a blur, so focusing the viewer's attention on the main subject.

When using a manual camera you should select a medium range aperture/shutter speed, then move it perhaps one or two f-stops towards a faster shutter speed/wider aperture to give the same effect. If you are working in overcast conditions, or with the sun to your subject's back, consider using fill-in flash to give some life to the portrait. It brightens the colours on just your subject, and puts catchlights into their eyes which makes for a much more lively looking image. It is important to avoid

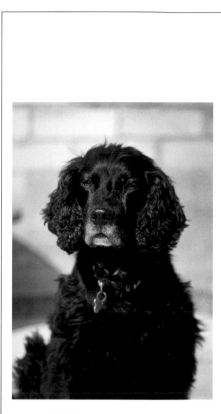

ABOVE **Portraits do not have to be restricted to people. Animal portraits work well both as more formal images . . .**

LEFT **. . . or as pictures that capture more of the animal's character.**

ABOVE **For flattering results when photographing people, there is always the faithful 81 series warm-up filters for adding a light tan on overcast days.**

RIGHT **A diffuser gives a more soft-focus look.**

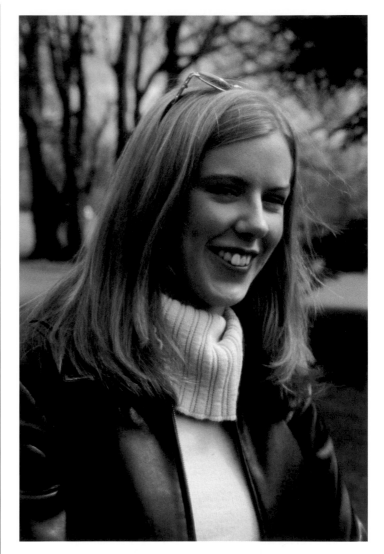

flat dark eyes on your subject as this is often the first feature people notice about a person so they need to convey some depth and emotion.

How you pose your subjects also has a major bearing on the success of your images. The subject must look and feel relaxed and natural if their portrait is to be a success. Placing someone in a familiar environment is the ideal way to achieve this. If your subject likes hiking, take a picture of them wearing their walking gear in a rural environment, if they like sports take a picture of them in action, if they are an artist, capture them painting at an easel and so on.

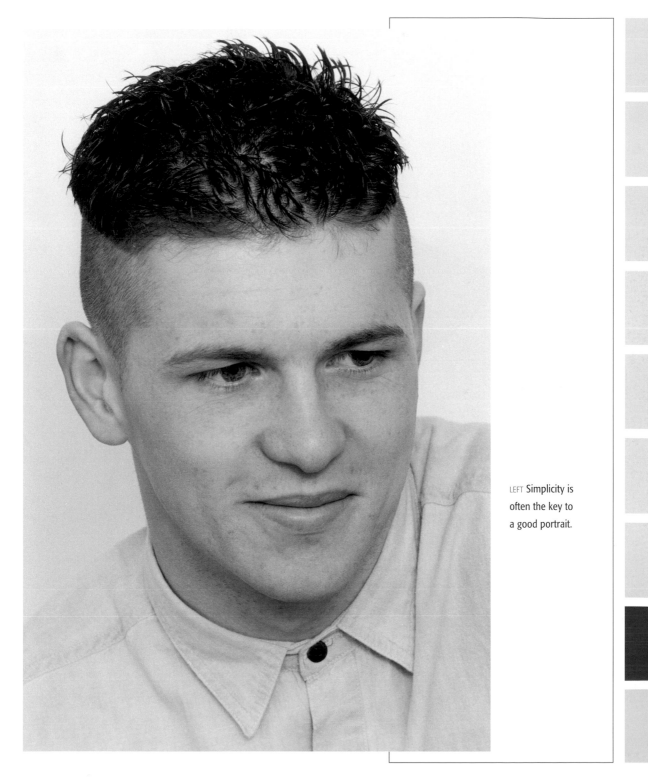

LEFT **Simplicity is often the key to a good portrait.**

RIGHT **Children** are one of the hardest subjects to photograph. Let them dress as they normally would, and give them a prop to keep them amused.

When photographing pets decide whether the effect you want to achieve is a formal portrait with the animal sitting up straight or a more natural image of the animal curled up asleep or playing.

There is a temptation to try and capture your subject smiling, but this is not always easy. Faced with the unnatural situation of posing for the camera most people's 'on demand' smiles will become forced and affected. Maintain a dialogue with your subject to help them relax, and when working with children, consider using props to hold their interest and amuse them. One professional advocates making your subject blow a raspberry at the camera in order to make them laugh and to do away with any tightness around the mouth.

The ultimate challenge in portrait photography is usually regarded as the studio portrait. Given one or two

ABOVE **Props are also useful for portraits of adults, transforming a classic photograph into something a little bit different.**

RIGHT **If your subject feels relaxed in the outfit they are wearing, you will get a more natural result from the shot.**

ABOVE **Some people have what can only be described as black and white features. Strange but true. Learn to spot them and wonderful black and white photographs will be your reward.**

studio flash heads and a few suitable tools you can produce really professional pictures of single people or small groups and get very precise results. The downside of studio work is that it lacks spontaneity and many people simply cannot relax when faced with a barrage of bright lights. A focal length of around 85–135mm is ideal for head and shoulders

ABOVE **Don't be afraid to include more than one person in your portraits. Sisters will often enjoy being photographed together.**

portraits. This gives a flattering perspective to a person's features and allows the photographer to stand a comfortable distance from their subject. Any closer with a shorter lens setting can lead to distortion of the subject's features (a stretched nose is a typical example) and make the sitter feel uncomfortable at the close proximity of the camera. Save the shorter settings on your standard zoom lens for longer figure shots and small groups.

Make sure your sitter is comfortable. The room should be at a reasonable temperature, and some quiet background music can be relaxing. Allow the sitter to dress as they want so that they feel comfortable and provide a mirror so that they can check they are happy with how they look before you begin. Always shoot more film than you think you need to. At least one full film is a good maxim so your subjects have time to relax and get used to all the flashing lights.

ABOVE **When the weather takes a turn for the worse, do not put your camera away. Stunning close-up images like this are available in the garden all winter round.**

The traditional pair of umbrellas will do just fine. Place your lights at 45° to your subject, one on either side. This will give a smooth, even light capable of showing detail in your subjects. Once you have managed good results with this set-up you can start to experiment. Cut down the power on one of your lights to give some pronounced shadows. The lower-powered lamp is now just a fill-in to stop the shadows becoming too harsh. If you want to create a really stylized piece then turn the fill-in light off completely. The single light will reduce your subject to hard highlights and shadows. Not to everyone's taste, but an interesting photographic trick to experiment with.

Outdoor subjects suitable for your macro shots are plentiful. Bright spring and summer flowers, autumn seed heads, dew on spiders webs. They are all fascinating macro subjects. To make the best of them avoid photographing

them when the sun is at its height, and consider using some form of portable reflector to bounce some light back into the shadows of your subject. Other than that, you cannot do much to change the composition so stick by the old rule of filling the frame with your subject and aiming for the best depth of field that you can manage.

Street photography

One of the earliest examples of a person being recorded on film took place in a picture taken on a street. In those early days exposure times were measured in seconds or even minutes, so images of buildings and landscapes were readily captured, but any people in the scene passed through and were gone before they could be recorded. One figure in a picture of a French street scene paused to tie his shoelaces, and by staying still for those few magic seconds became perhaps the first person to be photographed in the street.

Others have made a profession of taking pictures on the street, and the fascination remains today. A walk down the street on a Saturday afternoon can yield all sorts of interesting photographs. Buskers, street entertainers, celebrations,

LEFT Buskers are a likely subject for street photography.

BELOW Less-conventional street performers are common in tourist areas, and can make effective subjects.

RIGHT Once you have got your first image, feel free to take a pace back and think about how you could improve your photograph. By waiting until he moved, and stepping in a little closer, a better second picture was obtained. But always take that first, quick photograph as you may not get a second chance.

parades, protests, they are all out there for you to photograph. Even the occasional unusual item of street decoration or market stall can make an interesting photograph.

Take your basic camera kit. The body and standard lens should be enough as you are not going to be able to stand back to get your photographs. If you try, a wall of people will soon form between you and your subject and the moment will be lost. So leave that long telephoto zoom and filters at home and travel light for a change. Fill any odd spaces in your bag with film as you will be surprised how

much you will find to photograph. The average exposure program on your camera should suffice for street photography, moving over to the portrait mode to give a shallow depth of field if your subject has a cluttered background behind them. Just remember the advice given right at the start of the chapter. Take your first picture as a reflex, then think about how you can make it better by fiddling with your camera's controls and/or the composition. Once that elusive moment has passed it will be gone forever. Better to have a poor picture than none at all.

If you are trying to blend into the background, forget about using flash. Nothing attracts attention like a bright flash of light, and it can easily irritate other people. Turn off

RIGHT Don't be afraid to come back on another day, as you may find the performer has variations in his act.

BELOW Stand back from your subject, and capture them in their environment by showing other people watching them.

ABOVE **You do not find just people on the street. Some advertising gimmicks are worthy of a photograph in their own right.**

RIGHT And keep an eye on those gimmicks, they sometimes change for special occasions!

your on-camera flash if your camera has one, and leave any bigger flashguns you might have at home.

Consider situations carefully when taking pictures of people without first asking their permission in order to catch them in an entirely natural situation, often known as 'candid photography'.

Be prepared to justify your actions to those you are shooting if need be and be sensible about the type of people you choose to shoot. If a situation appears in any way threatening, avoid it. Street entertainers who willingly put themselves in the public eye are unlikely to object, and they often make bright and colourful subjects.

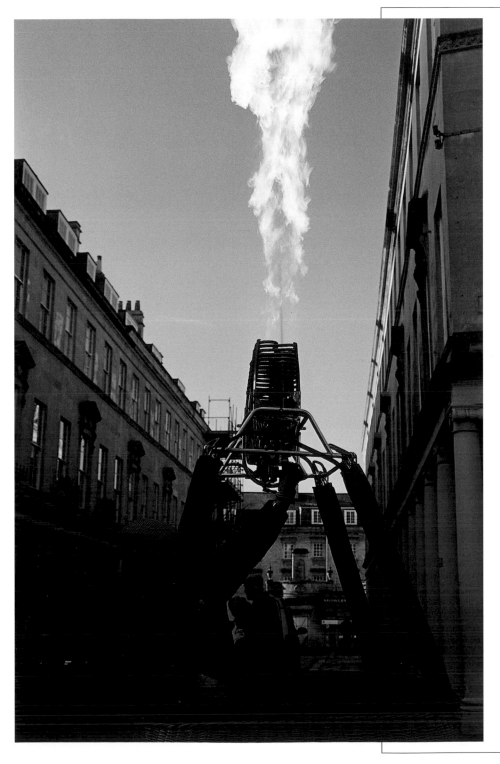

LEFT Advertising stunts can make interesting pictures, like this man promoting his business by offering balloon flights.

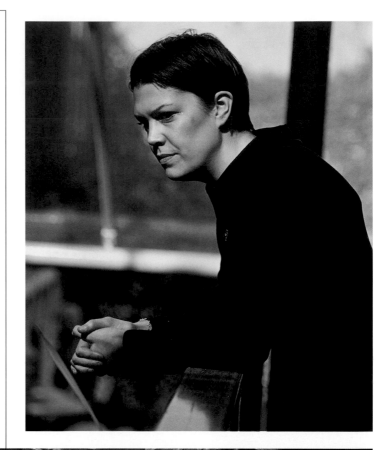

RIGHT **Candid photography is a hard discipline to master as you have no control over the subject and what they are doing. And always be aware that they might not be too keen if they notice you taking pictures of them without their expressed permission.**

RIGHT **Always keep your eyes open for simple abstract pictures as you walk the streets. Like the play of light on wet flagstones.**

Black and white

Though not a specific subject in itself, black and white photography does need a subtly different technique if you are not to end up with pictures that look like they should have been taken in colour. When taking pictures in black and white it is effective to look for more graphic images than when taking pictures in colour. When you are working in black and white you should be looking for things like textures and patterns, such as the brickwork of buildings, the play of light on the chrome of a car, the light and shade patterns appearing on the fronds of an evergreen tree. Look out for subjects that will benefit from the definition that you can add by taking black and white images of them. It is also the case that some people look better in black and white than they do in colour. A person who looks fairly conventional when photographed with colour film can be far more striking in black and white. It is

BELOW Black and white principles can be used with colour film as well. There is no colour in this image to speak of, yet the pleasing mixture of tones and textures makes for an interesting picture.

ABOVE **Patterns can be found everywhere. The repetition in this line of motorcycles makes an interesting pattern that colour may have distracted from.**

always worth shooting a few frames in black and white when you are conducting a portrait sitting. You might be surprised by the results.

Black and white film is also handy if your subject has an overly bright or permanently 'flushed' complexion. Black and white film will do away with much of this unwanted colouring to give a more flattering result. Just make sure your subject will welcome that result. Sometimes people want to see themselves as they are, no matter how unflattering the result might look to you.

Coloured filters add a whole new dimension to black and white film. As discussed in Chapter 6, the addition of a simple solid coloured filter can subtly change the look of a black and white photograph. A deep red will give you a very dark sky if the original was blue, while orange or yellow will give more natural-looking skies. The way people look can also be changed quite markedly. Freckles disappear with the application of an orange filter, and a red filter can turn your models a deathly pale shade.

You can make your blue paintwork look far lighter or darker as you see fit. And you can make a subject stand out against its background by using the same technique. The same mid-tone blue car will blend into a background of mid-grey stonework. By adding that blue filter you can make it look lighter and stand out more against the background. Which brings us to a quick point to save money with black and white. As mentioned way back, black and white processing is more expensive than colour as there are so few commercial labs offering the service these days. Ilford films created a solution to this, and the likes of Kodak quickly followed their lead with colour process compatible black and white films. Ilford call theirs XP2, while Kodak's is called T400CN. Both give similar results and your choice is very much a matter of taste. As a rule the Ilford product is easier to come by, but this very much depends on the size of your local camera shop and their particular allegiances in the film world.

ABOVE Always be prepared to take more than one picture of any given subject, especially in the world of black and white, as you can never be completely sure how things will turn out. This picture was taken from the other end of the line of motorcycles.

'It is worth bearing in mind that when C41 process black and white films are printed on colour paper they can sometimes take on a slightly brown tint'

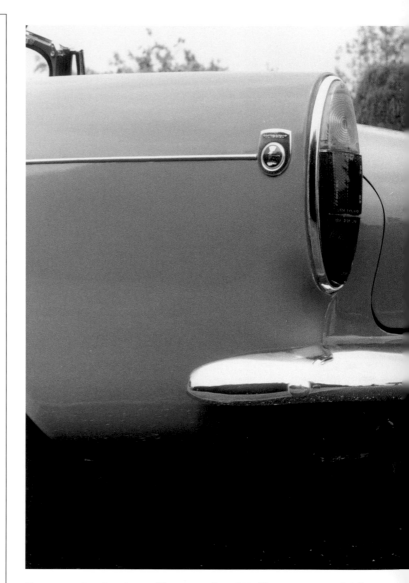

Put very simply, these films use the C41 film process, which is the same as with colour print films. They retain the shadow and highlight detail layer, but discard the three (or sometimes four) layers that retain the colour information. The result is a black and white negative with the cost of colour processing. The only snag is that some small labs seem reluctant to process C41 films through colour chemicals. Be polite but firm and hopefully they will agree to do this for you. It is worth bearing in mind that when C41 process black and white films are printed on colour

LEFT Black and white photographs work well in instances where detail is more important than colour.

paper they can sometimes take on a slightly brown tint that is not in itself unattractive. You still get a perfect set of black and white negatives from which you can have prints made at some later stage. You might even choose to hire a darkroom and do them yourself and we will look at this in more detail in Chapter 9. The other snag is that coloured filters do not work in the same way with the C41 processed films as they do with 'conventional' black and white films. So if you are planning on doing serious filter work, you will need to stick with conventional black and white film.

ABOVE The basic kit required to process your own black and white films. A developing tank, film spool, mixing cylinder and a thermometer. Add three chemicals with water and you are ready to turn out your first black and white film.

If you have read and practised everything in this book, then you will no doubt be feeling inspired to develop your skills even further. In this chapter you will find some ideas to help you do this. Some of them may require you to purchase pieces of equipment, but I have tried to keep suggestions where this is necessary to a minimum. The main purpose of this chapter is to inspire you to move on with your photography.

Processing your own black and white films

Although taking this route is not cheap, it is the best way to get impressive results and to train your eye for the kinds of images that are effective. The actual processing of black and white films is not difficult. All you need is a light-tight processing tank, a dark bag for loading the film into the tank, a film strip retriever, a thermometer and three chemicals. The total time for processing each film will be around half an hour.

When you put your black and white films through a modern amateur lab they are processed on an 'average' basis, no matter what the film is. Yet if you look at the instructions that come with any bottle of developer you will see that they list different developing times for every film type. Just by using the 'correct' developing time you should get better results from your black and white films.

You will need to set up a darkroom area, but the basic process is simple. Before loading everything into the dark bag (which is a sort of portable cloth darkroom), you use the film strip retriever to get the tip of your film back out of the cassette and trim its end so it is straight with rounded edges. Now put the cassette, along with the developing tank, all its bits and a pair of scissors into the bag. Zip up the bag, and now begins the only tricky part of the exercise – loading the film onto the spiral that goes in the tank.

Makes of film vary in how easy they are to work with, but as a general rule you press the film leader into a feeder slot on the spool and move the sides of the spool back and forth to mechanically pull the film out of the cassette and onto the spool. Once all the film is on the spool take the scissors and carefully snip off the remains of the film from the cassette. It is clipped to the spool inside the cassette and will not come off on its own. Now all the film is on the

Onwards & upwards

spool, clip it into the tank, screw the light-tight lid on securely and bring the tank out into the light. The rest of the process is easy.

Prepare the three chemicals – developer, stop bath and fixer – as per the instructions, and pour them into the tank one after another for the appointed times, and once you are done, you will be rewarded with a nicely processed strip of negatives. If you are serious about developing and printing black and white images it is worth seeking out a technical book on the subject, or consider enrolling in an evening class for one-on-one expertise. If you do choose to go down this road, incredibly good black and white prints will be your reward and you will be the envy of all those who still have to use commercial black and white processing services.

Infrared/SFX film

Some very creative and atmospheric effects can be achieved with infrared film. Infrared light exists beyond the visible spectrum of light, and reflects heat as well as light. Infrared was developed in order to record that light for scientific purposes but it can also be used to create extremely strange and artistic images. Available in both colour and black and white, both forms work on a similar principle. Things that reflect infrared light record as light areas in images, while those that do not reflect infrared record as very dark. When

BELOW Using Ilford SFX/infrared film can produce strange, unearthly results like this. Blue skies record darkly as they reflect very little infrared radiation, and foliage and people's skin record as bright tones as they reflect plenty of infrared radiation.

RIGHT Other scenes, where there is little foliage or sky detail, can record deceptively normally, even if the grass is near white and the water unnaturally dark.

using black and white infrared film, complexions and foliage record as very pale as they both reflect infrared light, while water and blue sky record almost black as they reflect none.

Using colour infrared film will create even stranger images. Grass and trees can record anywhere from white through to strange shades of blue and silver. While infrared film is an excellent medium for weird and wonderful images it does require rather stringent handling. It must only be handled in complete darkness, this includes when loading and unloading the film from your camera. This process must take place either in a photographic darkroom or in a dark bag if you wish to change films on location. Processing is also a problem as very few processing houses (amateur or otherwise) are prepared to handle it. Make sure you can get it processed locally and at a sensible price before you use it.

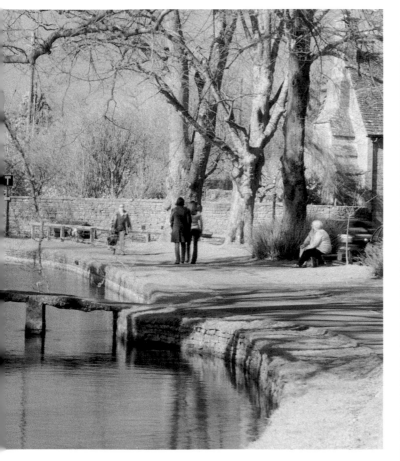

There is one final point to consider before you use infrared film – your camera. Not all cameras were created equal where infrared film is concerned. Some make use of a tiny beam of infrared light in their frame counting system and if your camera is designed in this way you cannot use infrared film as it will fog. If there is no mention in your camera manual of this, check with the manufacturers; it might save you a lot of disappointment and wasted money in the long run.

Ilford films have come up with a solution to most of these handling problems with their SFX film. This is a conventional black and white print film with an extended sensitivity into the red area of the spectrum. Which effectively means that it acts like a black and white infrared film without the usual handling problems. It can be loaded in subdued light, and processed by any lab offering a black

'Ilford films have come up with a solution to most of these handling problems with their SFX film'

ABOVE Straight head and shoulder portraits are popular among the amateur dramatic fraternity.

Publicity material

Once you have mastered the basic art of your photography, you may want to consider making some extra money by offering your services to local businesses or groups for their publicity material. The main thing that will be required here is a sharp, correctly focused and correctly exposed photograph. There are a lot of photographers out there whose equipment and bravado outstrip their abilities, and you do not want to be one of them. Charge reasonable expenses and a modest reprint fee if they want more prints at a later date. If your photography is used in print anywhere, for example in the local paper or a show program, make sure your name is included with it. The first time you see your name in print will give you a real boost and inspire you to develop your skills further.

Exhibiting work

As you build up a body of work, you may feel that you would like to share it with others and get feedback on it. There is a simple way to remedy this and that is to put on an exhibition of your work. Contrary to what is often believed, this will not, unfortunately, make you any money. Indeed, it will cost you money. You will have to have a selection of large prints made then mounted and framed and this can be very costly. It is worth trying to negotiate a special price with a framers when getting a number of pieces framed at once.

Public libraries are a good first port of call when seeking somewhere to exhibit as they often have exhibitions of local artists' work. Other venues might include camera shops, small galleries, coffee shops, small restaurants and perhaps even your bank. If they are interested, have some images available for them to look at, and be prepared to talk dates on the spot. Think about what material you are going to put up and make sure it is appropriate to the venue.

Ensure that your images are suitably marked with your name, and include your name and address on the back of each image. The likelihood is that once you take your exhibition down you will hear nothing more about it, but occasionally word of your work may spread and you may be asked to put on a subsequent exhibition. You may even get a commission or two to shoot similar images for a fee.

Make your own calendars and cards

If you have built up a good portfolio of images of friends and family you may consider compiling them to create a personalized calendar, or if you don't have enough suitable pictures for this you could make cards instead.

For small numbers you can simply buy blank cards and calendars from your local stationer or photography shop that allow you to slot in images of your choice. You will then just need to get a suitable number of prints made from your negative at the appropriate size. Bear in mind that you will have far higher printing costs when putting together calendars, so do not be over ambitious about how many you decide to make. If your calendars are popular you may want to plan images carefully around them over the following year so that you have an image taken in each month.

They can also produce your cards on a computer. Ask a local camera shop to scan your negative onto a CD then load it onto your computer. Print the images on a heavy-grade inkjet paper and attach them to card as desired.

BELOW A simple record picture of a high street that could be anywhere. But what was there before those traffic lights and strange islands. In ten years' time, your picture could be answering those questions for a whole new generation, and you could be making money from reproduction fees.

167

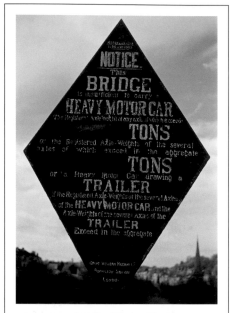

ABOVE AND RIGHT Details of the local landscape are often ignored until they are gone. By expending a frame or two of film to record these little details, you may have a chance to sell the pictures to local publications in years to come as a reminder of the way things once were.

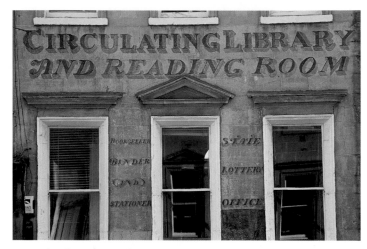

Local places and customs

Find out about customs that are specific to certain areas and document them – they may well be of interest to local publications, and unique events always make interesting subjects to capture on camera. Likewise, the changing look of your area is always a subject of interest. It may be that in a few years' time, when the old cinema has been rebuilt or a car park has replaced old houses, your photographs will become a historical reference. These kind of shots are an exception to the rule in that filling the frame is not so important as getting everything level and getting everything in to provide a clear record for reference.

Selling your work

There are many opportunities to put your images forward to be used in books, magazines and papers. The Internet publishing world is also growing at a striking rate and consequently requires more and more images. If you can provide pictures that are sharp, in focus and correctly exposed you are in with a good chance of being able to sell your work.

The medium of choice for the publishing world is the slide, so if you have previously only worked with negative film, you will have to make a switch in order to make your images marketable. General images snatched from stock very seldom sell as they were not aimed at any specific market when they were taken. Pick a magazine you think you could take pictures for, and take a roll or two with their

ABOVE Oddities and modern art will always be a talking point, so if you come across any, record them for posterity.

exact requirements in mind. Make a careful mental note of
their general style, and what sort of things they publish
photographs of. Big feature articles probably came with
photographs supplied by the author, but there will be lots of
filler images that you might aspire to supplying.

Whole books have been written on the finer points of
selling your work, and if you want to find out more, I urge

ABOVE This easily set up picture had outlets in the
modelling and the gardening press.

ABOVE AND BELOW Newsworthy events are always worth recording if you have
a camera handy. The floods in Bath were muddy and disruptive, as these
before and after pictures show.

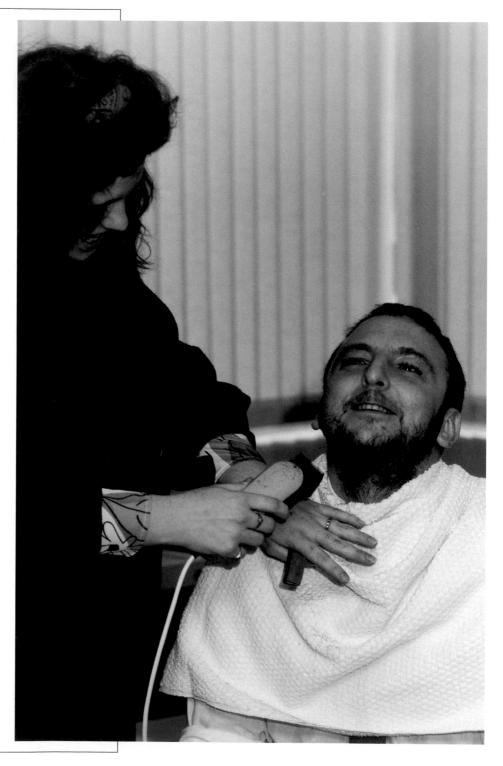

RIGHT Charity events often demand the services of the keen photographer to make their mark on the world. Company magazines, local papers and even the charities themselves are always looking for decent photographs to illustrate their work.

you to seek one out. Just remember that everyone has to start somewhere, and most of today's professional photographers started life as struggling amateur photographers just like you. So take heart.

Scanning your images

This is a vast area, so here I have provided just a brief guide to starting out. With a suitable photographic quality printer you can turn out prints exactly as you would like them. With no intervention from the commercial labs. You will be repeatedly amazed by the amount of detail hiding in your negatives when you pass them through a scanner and print them out for yourself. Until recently, the only way to access this hidden detail was to print them yourself in a home darkroom, which is quite an undertaking for colour work. Now, with the arrival of cheap scanners, everyone can do it at home.

As you will have gathered from the above paragraph, the best way to get your images onto your computer is with a scanner. Ideally a dedicated negative/slide scanner. Your camera shop will be able to get your negatives scanned onto CD at the same time as you have them processed, but the results are usually not as good as scanning them at home with a decent quality scanner.

Scanners range in price from the surprisingly cheap to the frighteningly expensive. Check out brands like Nikon, Canon and Minolta for the best quality devices, and be prepared to pay extra for automatic software to remove dust spots and scratches from your scans. Once you have the raw scan on your computer hard drive, save a second copy to work on. Never, ever do anything to the raw original. That way you can always throw away your altered version and start again with a freshly saved copy if everything goes horribly wrong. Once you have your image scanned and on file you will be able to change its size, brightness and contrast, cropping and even its colour balance.

So where do you go from here? In your 35mm SLR you have a versatile camera capable of taking pictures of just about anything. Don't be scared to experiment, copy the work of others and adapt the equipment you have to do the best you can. The main thing is to get out there with your camera and have some fun.

ABOVE Getting your pictures onto your computer for all sorts of reasons is easy with a dedicated film scanner. While not as cheap as a flatbed scanner, they give far better quality results. The alternative is to have your negatives scanned at the processing stage by your camera shop.